Painting Perspective, Depth & Distance
IN WATERCOLOUR

Geoff Kersey

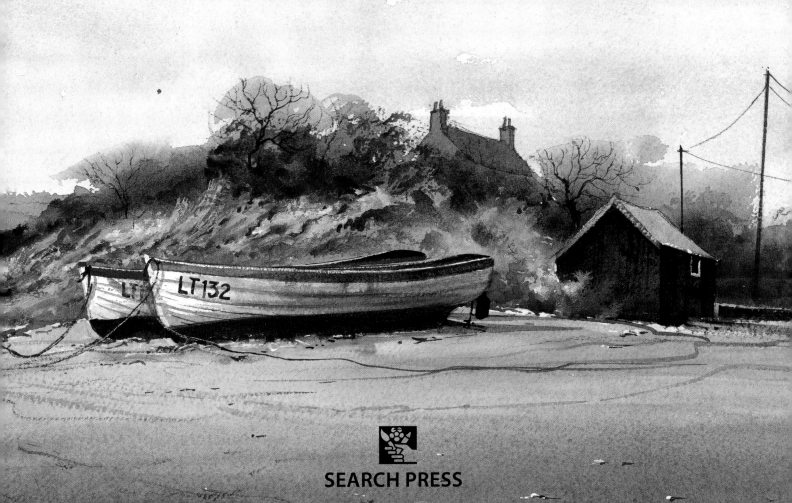

SEARCH PRESS

Originally published in Great Britain 2004 as
Perspective, Depth and Distance

Search Press Limited,
Wellwood,
North Farm Road,
Tunbridge Wells,
Kent TN2 3DR

Text copyright © Geoff Kersey 2017

Photographs by Charlotte de la Bédoyère at
Search Press Studios, except for those on pages 9–14,
18, 118–127, 131–141, by Paul Bricknell.

Photographs and design copyright
© Search Press Ltd. 2017

ISBN 978-1-78221-311-6

The Publishers and author can accept no
responsibility for any consequences arising from
the information, advice or instructions given in
this publication.

Suppliers

If you have difficulty in obtaining any of the materials
and equipment mentioned in this book, please visit
the Search Press website for details of suppliers:
www.searchpress.com

Publishers' note

All the step-by-step photographs in this book feature
the author, Geoff Kersey, demonstrating how to paint
in watercolour. No models have been used.

Printed in Malaysia

Page 1

Boatyard at Woodbridge

340 x 270mm (13½ x 10½in)

Here the positioning of the boats leads the eye to the
distant area just to the right of the whitewashed building.
Note that the planks of timber at the bottom right plus the
suggested lines on the yard also point to this area. There is
no mistaking where we are meant to look in this scene.

Pages 2–3

Dunwich Beach

610 x 394mm (24 x 15½in)

I love to paint this type of scene, so typical of the Norfolk
and Suffolk coasts, where the landscape is dominated by
huge skies. Note how a second glaze was used after the
first one had dried, leaving a small area in the top third
where the viewer glimpses a patch of light. The small
cliffs, old hut and beached boats lend just enough interest
without making the scene too cluttered.

Opposite

Bluebell Wood

305 x 446mm (12 x 18in)

Unusually for me, this scene has not even a glimpse of sky
– instead the mass of greenery encourages the viewer to
focus on the carpet of bluebells, created using a mixture
of cobalt blue and cobalt violet. Note how the positioning
of the trees uses linear perspective to lead the viewer into
the painting.

Contents

Introduction

The fact that you have picked up this book and started reading this page indicates that the types of paintings you are interested in are representative. You probably want them to look like a real place, perhaps to evoke a feeling of being there, or to remind you of a place that you enjoy, that makes you feel good. To this end a good knowledge of perspective, both linear and aerial, is a vital foundation.

To form an accurate representation of a place and to evoke a feeling of being there however, are not the same things. At first if your painting works on a purely representational level, this in itself can be quite satisfying, and as you practise techniques, becoming more and more familiar with the medium and how it behaves, your accuracy improves.

You may (as I have) hear the comment, 'Isn't it realistic? It's like a photograph'. Whilst this is usually meant as a compliment, as an artist you should want to achieve more, aspiring to capture the atmosphere, mood, and that vital impression of depth and distance that makes the viewer feel involved in the scene, almost as though they could walk into it.

I found that when I took up landscape painting, it gave me a whole new interest in the countryside. I enjoy walking a lot more and am constantly on the lookout for fresh inspiration and new subjects. I notice with satisfaction the same growing enthusiasm in my students, arriving at class enthusing about the sky they have just seen on their journey, analysing colours in a dry stone wall or a tree trunk, where once they saw just brown or grey.

Certainly watercolour landscape painting can be a source of great pleasure, especially as we all enjoy success and the compliments of our peers; conversely we can soon become frustrated and disillusioned if it is just not happening. With the examples, illustrations and instructions in this book, I hope I can encourage you to achieve the results to which you aspire.

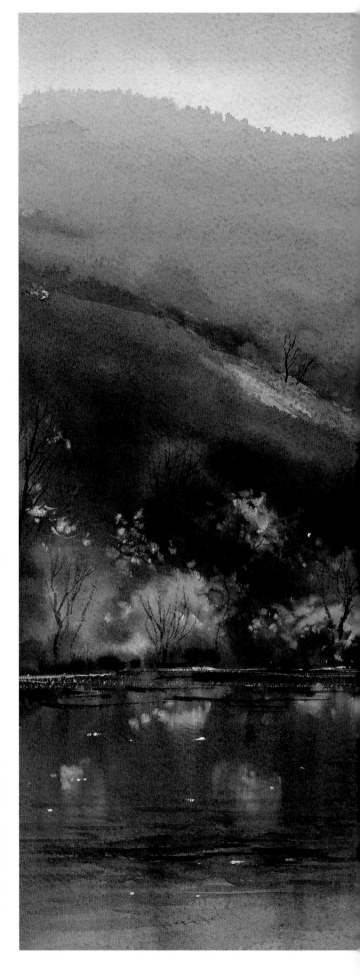

Miller's Dale, Derbyshire
406 x 305mm (16 x 12in)

A limited palette of just four colours has been used here to create a harmonious effect, giving the scene a feeling of calm. I used phthalo blue, lemon yellow, aureolin and burnt sienna. I do not use phthalo blue very often as it is a very strong dye that can overpower a painting, but it does make good blue/green shades with just water added and rich dark greens when mixed with burnt sienna. I added touches of white gouache with lemon yellow in places to create a light on top of the dark. Note how a feeling of distance has been created by rendering the furthest hill with the same thin blue wash as the sky.

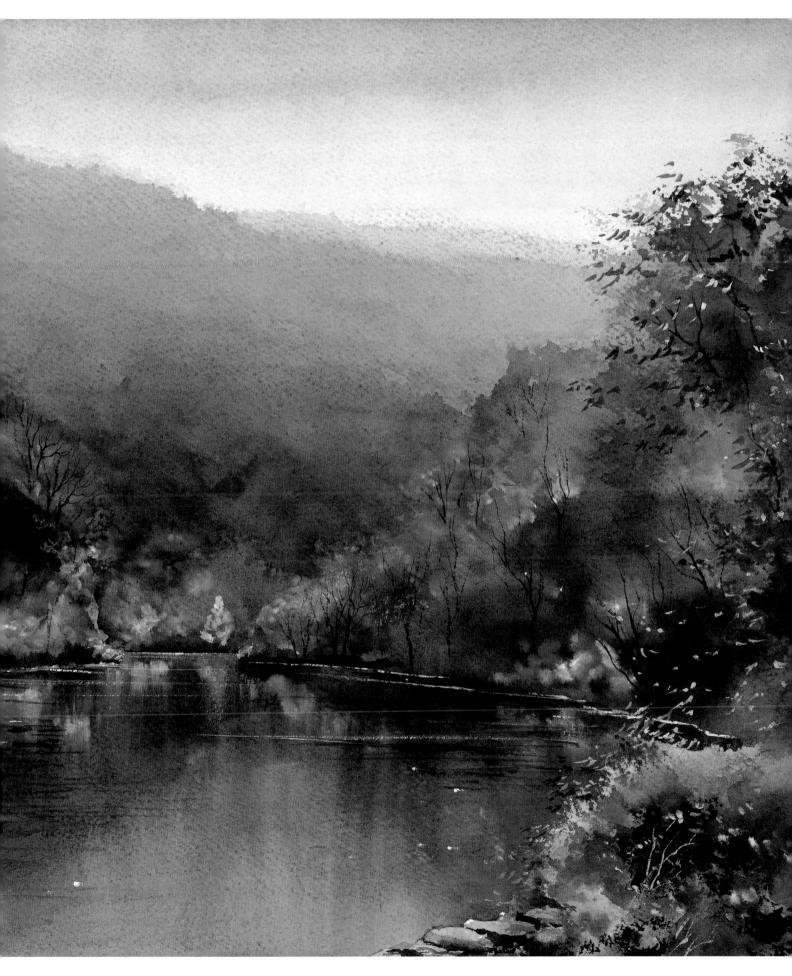

Materials

When you visit your local art shop for the first time, you are overwhelmed by the enormous variety of materials available to the watercolourist. There are papers by different manufacturers in blocks, pads and loose sheets, in four or five different sizes, three different textures and numerous different thicknesses. Paints come in several brands, in pans or tubes, large or small, in pre-selected sets or loose. The range of colours is enormous: nine or ten different blues, seven or eight different yellows and reds. Brushes seem to vary greatly in size, shape and particularly price, and while this bewildering array of products gives you plenty of choice, there is no wonder that beginners often start by buying products that they later wish they hadn't. With this in mind I want to look briefly at the materials I recommend.

Paper

I believe paper has the biggest effect on the finished result. Choosing the correct paper can make certain effects much easier to achieve. There are basically three surfaces, HP (hot pressed), Not (sometimes referred to as cold pressed) and Rough. To simplify this, think of them as smooth, medium and rough.

My personal preference is for Rough paper as you will see throughout this book, but a medium (Not) surface usually has enough texture to work with. I would not, however, recommend HP (smooth) paper for landscape painting as you don't have the benefit of the 'tooth', making certain dry brush effects almost impossible.

Students often ask me, 'What is the difference between a rag or cotton and a pulp-based paper?' To which my answer is, 'The price!' However, if you can afford to pay extra, it really does pay dividends. Rag-based paper is much tougher and more resilient; it is a joy to use. Look for good brands and don't buy anything lighter than 300gsm (140lb). Even at this weight I always prefer to stretch the paper so that it doesn't cockle and distort when it gets wet. This involves immersing it in water for about a minute before laying it flat on the painting board, where you leave it for another couple of minutes, during which time it expands. It should then be pulled flat and secured to the board by gummed tape, or stapled. This ensures that when it contracts as it dries, it pulls taut, creating a beautifully flat surface, crying out to be painted on.

Not surface watercolour papers in loose sheets. I recommend Rough or Not surfaces for watercolour landscape painting.

A selection of round and flat brushes. Whatever their size, round brushes should have a good point.

Brushes

This is an area where I believe you can save money. I do all my paintings with synthetic brushes, apart from the extra large filbert I use for the skies, which is a squirrel and synthetic mix. My basic brush collection is as follows:

- *Round* numbers 4, 8, 10, 12 and 16

- *Flat* 1cm (½in) and 2.5cm (1in)

I also use a no. 2 liner writer or rigger. Check that this is very fine, as sizes vary according to brand. Ensure that all the brushes you buy have good, fine points, and when the point of a brush wears out, buy a new one, saving your old brushes for mixing, scumbling and various dry brush techniques.

 ## Paints

There are basically two types of watercolour paint: artists' quality and students' quality. I have noticed in recent years that students' quality paints have improved, but if you can afford the difference in cost it is worth investing in artists' quality. The colours are generally brighter and richer, as they have a greater ratio of pigment to gum arabic binder and so they go further, making students' quality to some extent a false economy.

Watercolour paints are available as tubes and pans. I prefer tubes to pans as they are in a semi-liquid state, making it much easier and quicker to mix plenty of washes for each stage of the painting. You will also find it much easier to vary the intensity of the colours with tubes. I squeeze the colours straight into the palette, where they are ready to use – as shown opposite.

Tube paints. I prefer these to pans as the paint is semi-liquid, which makes mixing washes quicker and easier.

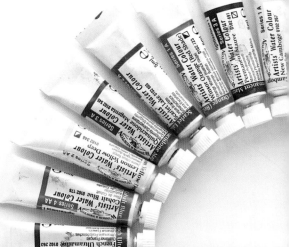

I use a large watercolour palette that I designed myself, with small, deep wells for the fresh, unmixed colour and large, deep wells for mixing. The palette has a tight-fitting lid, which also acts as a mixing tray, and a sponge membrane, which, when dampened with clean water, keeps the paints moist and ready for use.

It is a shame to invest in good quality paint, and then allow it to dry out. You can of course revive it with water, but in my opinion it is never as good or as easy to use as when it is in the semi liquid state. This palette is available from my website (geoffkersey.co.uk).

My basic watercolour palette is described below:	I occasionally add these other colours to my palette for particular moods or effects.
• Cobalt blue	• Cobalt violet
• French ultramarine	• Viridian
• Phthalo blue	• Burnt umber
• Aureolin	• Quinacridone gold
• Lemon yellow	• Neutral tint
• Naples yellow	• Vermillion
• Raw sienna	• Light red
• Burnt sienna	
• Rose madder	

 TIP

I use touches of white gouache to create certain effects, but this should never be put in your palette, or it will make the watercolours chalky.

Sketching materials

For sketching I use a spiral bound A4 cartridge pad, a 2B 0.9mm mechanical pencil and a putty eraser. I also find a 6B or 8B graphite stick or a large, flat, carpenter's style soft pencil very useful. Both of these are ideal for filling in large areas of tone.

Water-soluble pencils are fascinating to work with, and are especially good for creating quick tonal value sketches (see page 15).

Other materials

I have a variety of painting boards, mostly made of 13mm (½in) plywood. I also have a few made of MDF, which also makes good painting boards but is quite heavy and not ideal for carrying a long way. Hardboard or 6mm (¼in) plywood are not suitable as they are too thin and can bow if you stretch paper on them.

I use a collapsible water pot as it takes up less space, a bottle of masking fluid, which I find essential and an old brush to apply it. I have an old large brush that lost its point long ago, for cleaning the palette (don't use good brushes for this purpose as it blunts them), and a natural sponge for applying water to the paper.

Masking tape comes in handy if you want to mask a long, flat expanse, for instance a straight horizon on a coastal scene, and I use 5cm (2in) wide gummed tape or a staple gun for stretching paper.

A craft knife blade is useful for certain scratching and scraping effects, while a lightweight aluminium ruler helps with verticals such as boat masts and telegraph poles. A hair dryer can be used for drying washes if you are in a hurry, but I generally prefer to let them dry naturally, as the colours continue to mix and merge on the paper all through the drying process.

For painting outdoors you can avoid carrying a cumbersome painting board by buying paper in blocks, where the sheets are held in position with glue round all four sides. This makes it partly resistant to cockling, although in my opinion there is no substitute for stretched paper.

A painting board, metal ruler, gummed tape, masking tape, water pot, kitchen towel for lifting out paint, staple gun, pliers for removing dried-on lids from paint tubes, a craft knife and blade, old brushes for cleaning palettes and applying masking fluid, a sponge and masking fluid.

Drawing and sketching

To make a success of landscape painting, a knowledge of basic drawing skills is invaluable, as this is the underlying foundation of a satisfying and convincing picture. To make accurate drawings requires a rudimentary grasp of perspective and composition (covered in the next chapter), but to raise your drawings from simply accurate to lively and atmospheric depictions of what you see, you need to develop your powers of observation.

I often find people coming to my painting classes who say they can't draw when actually they are not looking thoroughly enough. Try comparing the height to width ratios of objects in the scene so the shapes look realistic. Look carefully at shapes and sizes; for instance, how many times does the length of a building or a tree go into the total width of the scene? These basics can be indicated with a few lines to make sure that the drawing is correct before continuing.

Drawing accurately is an ability most people can learn, but it takes a bit of application and practice. As you gain in confidence, the act of drawing becomes really enjoyable and no amount of time spent drawing and sketching is ever wasted as it hones your skills and sharpens your powers of observation.

Drawing and sketching is an excellent way to gather material from which to construct paintings. A full sketch book is a mine of information, which with accompanying photographs can provide the artist with subjects for hours of studio painting.

 TIP

Don't spend too long on each sketch; limit yourself to between fifteen and thirty minutes.

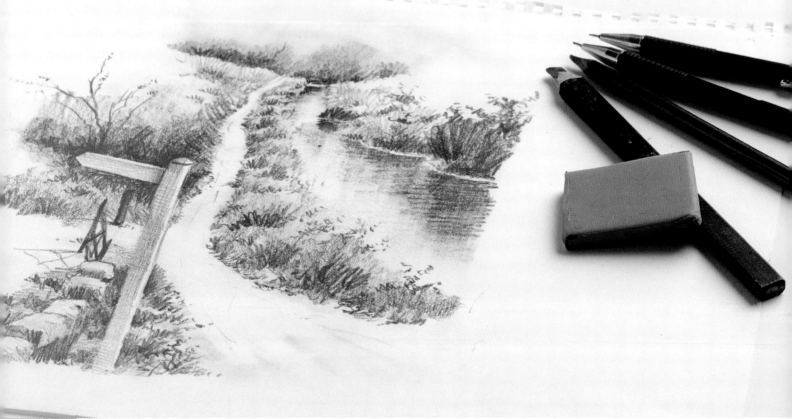

Tonal sketches

These are tonal value sketches, drawn quickly with ordinary graphite pencils. I use a 2B mechanical pencil and a 6B graphite stick which is excellent for filling in large areas of tone.

The fact that the pencils are soft means that you can explore a full range of tones from a very pale grey to a rich black (see the pencil swatches below). Don't forget to leave some white paper to contrast with the dark areas.

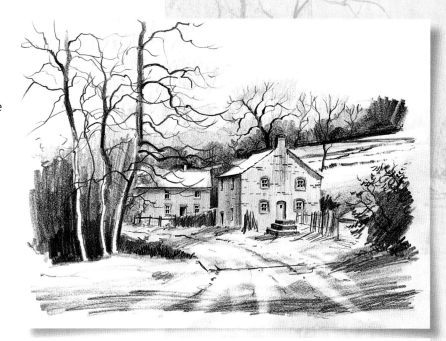

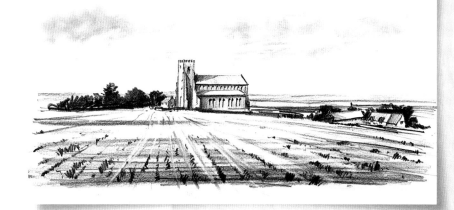

Explore the full range of tones from your pencil.

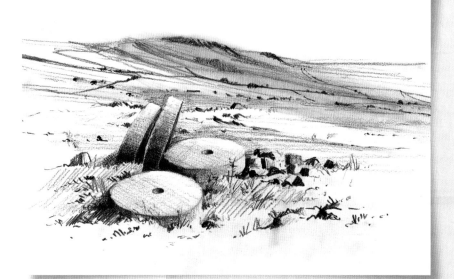

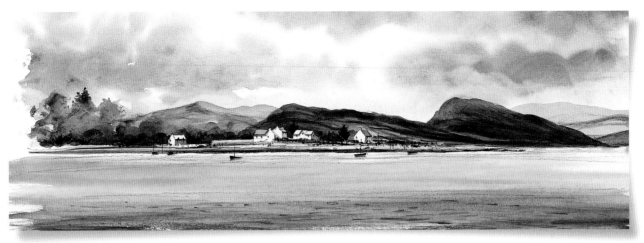

This long format sketch of Plockton, again, is all about tonal values. This time I have used a water-soluble (dark wash) graphite pencil which is very good for laying in areas of tone quickly. These pencils are excellent for experimenting with; I scribble some graphite onto the corner of the page and pick this up with a wet brush. As with watercolour, the more water you add, the paler the tone. In the final stage of the drawing you can tighten it up by working into it with both water-soluble and ordinary pencil.

A couple of hours at a boatyard or jetty producing quick sketches of boats will really pay off if you come to do a painting of a coastal scene. At first painting a scene that contains a lot of boats is not easy, but as you practise, you gradually gain an understanding of their shape and structure. Beached boats make more interesting subjects because of the variety of angles and the fact that more detail is visible.

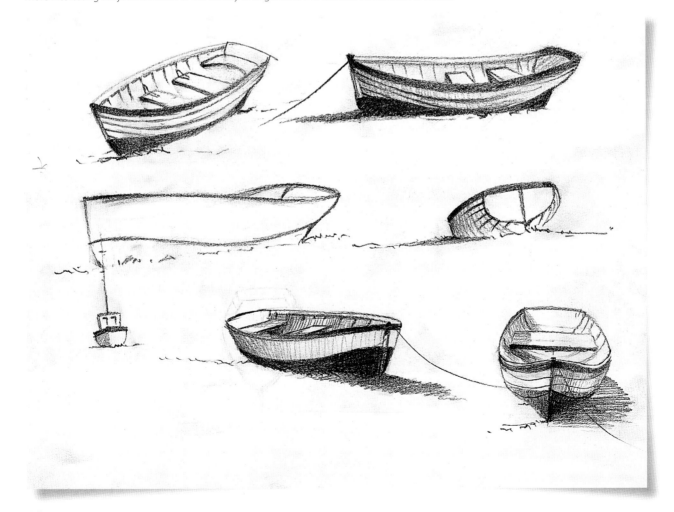

Sketching depth, distance and perspective

I enjoy doing the simple monochrome pencil sketches you can see here. I endeavour to not get bogged down or distracted with detail, preferring instead to establish the essential shapes and composition.

If something isn't quite right in the pencil sketch, you still have time to consider any alterations and potential improvements you can make to the subject, before committing yourself with watercolour paper and paint.

As you, the reader, are probably all too well aware, watercolour is not an easy medium to correct or alter, so anything that helps you understand and consider the composition more fully at the outset has got to be good.

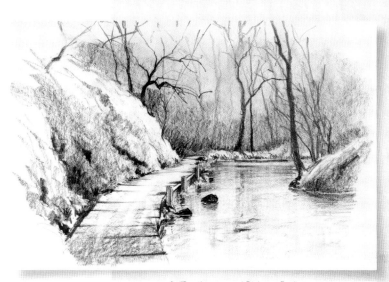

Sketching with watercolour paint

More often than not I work from photographs to create my watercolour landscape paintings, but I do still believe In the value of sketching and drawing. Whether you are working *en plein air*, or using a photograph for reference, it is worth taking the time to do a quick sketch using either pencil or watercolour, monochrome or colour.

If I am working outdoors, rather than aiming to complete a finished painting on the spot, I am more likely to do a quick sketch and take a photograph, with a view to using them both as reference material for a larger, more considered painting in the studio later.

In order to make these small reference or 'thumbnail' sketches, I have a small kit, consisting of watercolours in pans, brushes, a water bottle and a small palette. These are all very light and compact, and together with a small A5 pad of watercolour paper, very easy to carry around.

Even when working from a photograph in the studio, I think this intermediate stage of a thumbnail sketch is ideal to help you become more familiar with the scene you are preparing to paint, developing a better understanding of the colours, tonal values and perspective of your subject.

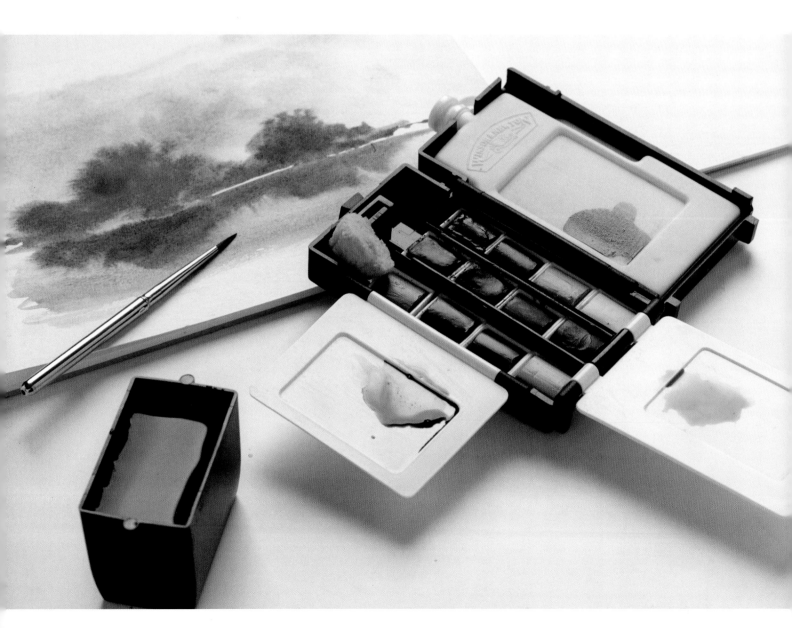

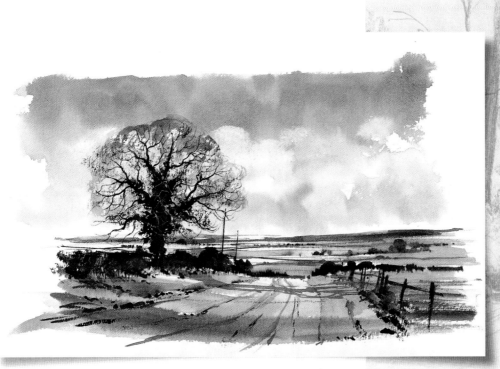

This very quick watercolour sketch is a monochrome, using just burnt umber. Having no other colours really makes you think in terms of tonal values; if your sketch is to have any impact, you have to explore the full range of tones available from almost neat paint to clear water. Choose dark colours such as Payne's gray, sepia and neutral tint for monochromes.

This is a half-hour watercolour sketch on tinted paper, containing sufficient information to work it up into a larger work later. I used white gouache on the walls of the farmhouse, which really makes it sing. Quick watercolour sketches, while untidy in places, can have a spontaneity often more difficult to capture in a more considered work.

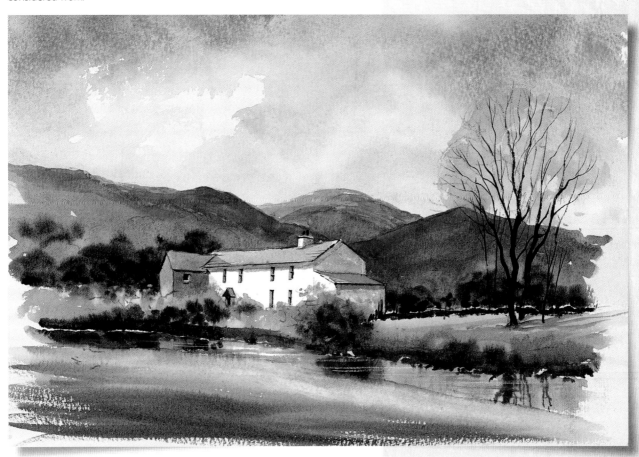

 # Using colour

These pages show a selection of colour mixes taken from my basic palette, coupled with some suggestions of how you might use them. You will find it easier if you mix them in the order they are shown, but it is not just about the colours used; the density of a colour should vary enormously depending on where and how you intend to use it. Don't be afraid to mix the dark colours nice and strong, without adding too much water.

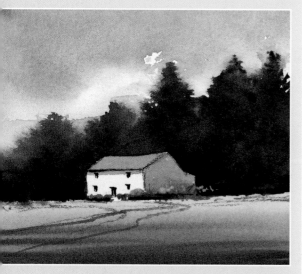

This small colour sketch shows how the three green mixtures can be used to create a feeling of light and distance.

Immediately in front of the cottage the pasture has been put in with the bright spring green, followed by the deeper green, then right across the foreground is a sweep of the rich dark green. This then sandwiches the bright strip between the dark foreground and the dark fir trees behind the cottage, helping with tonal contrast as well as perspective.

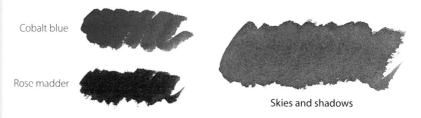

Cobalt blue
Rose madder

Skies and shadows

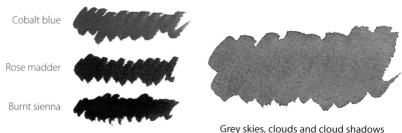

Cobalt blue
Rose madder
Burnt sienna

Grey skies, clouds and cloud shadows

Lemon yellow
Cobalt blue

Bright spring green

Aureolin
Cobalt blue

Deeper summer green

Aureolin
Cobalt blue
Raw sienna

Autumn green for cornfields and foliage

Aureolin
Burnt sienna

Autumn highlights – a bright, warm glow

Burnt sienna		
Cobalt blue		Autumn and winter darks

Burnt sienna		
French ultramarine		Very dark, ideal for twigs, branches and window panes

Viridian		
French ultramarine		
Burnt sienna		Rich dark green

Raw sienna		
Burnt sienna		
Cobalt blue		Rock and stone. The more blue added, the greyer it becomes

Naples yellow		
Raw sienna		Sandy beaches

Naples yellow		
Rose madder		A nice soft glow to take the whiteness out of clouds

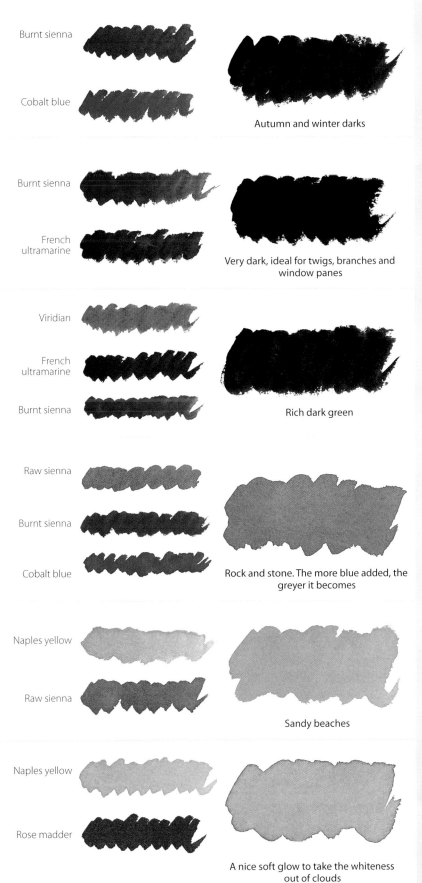

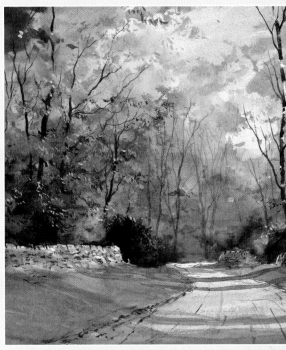

Here I have used the range of autumn colours shown on these pages. The burnt sienna mixed with aureolin creates an authentic, warm, autumnal glow, but note that there is still some green around. The rich, dark greens are carefully placed to provide maximum contrast with the light on the left-hand wall and the top of the right-hand wall.

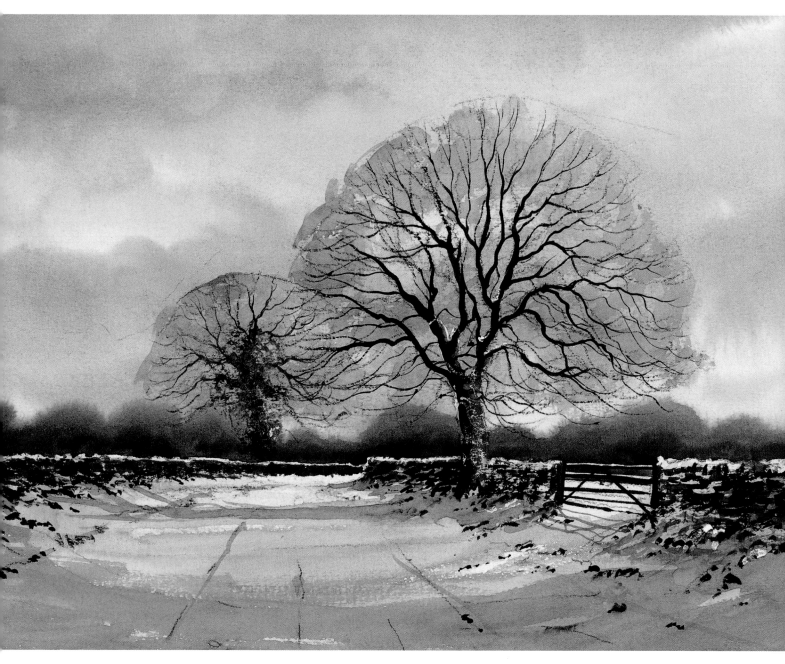

This snow scene makes good use of the medium and dark browns shown in the colour chart on pages 20–21. Be careful when mixing the very dark colour that you allow the warmth from the burnt sienna to show through, or it can look too grey and lifeless. Note how the more distant tree has been rendered with a paler, slightly greyer colour to push it back into the middle distance, and the distant woodland is represented by an even paler, greyer mix. In this way, colours are used to create aerial perspective.

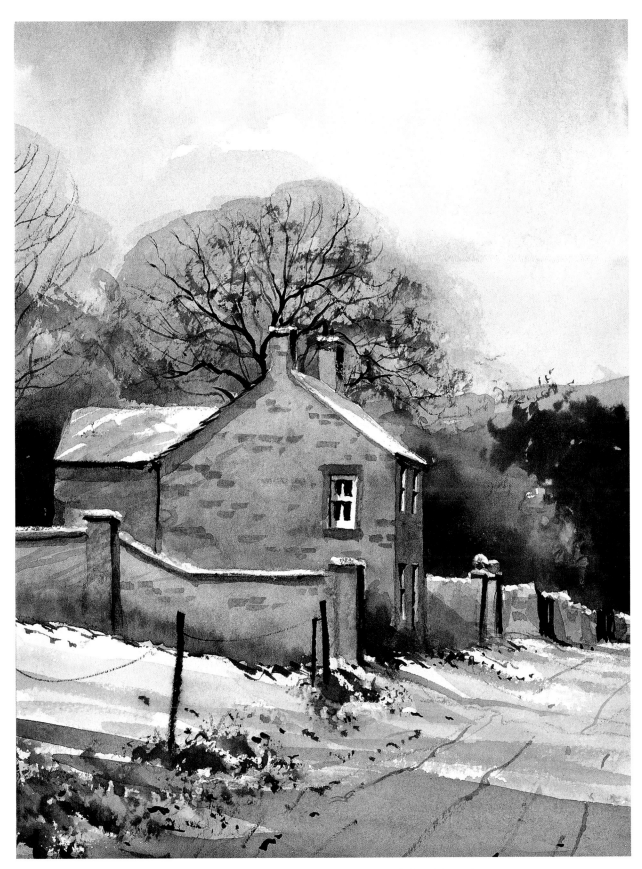

In this stone cottage I have used raw sienna and also burnt sienna with the addition of a touch of cobalt blue for a slightly darker colour to suggest the stonework detail. It is important not to overdo the detail in a painting like this.

Notice how a thin glaze of cobalt blue and rose madder, matching the sky, is used to create a shadow on the front of the building, giving it a three-dimensional look.

Linear perspective

To construct an authentic-looking landscape, you need a rudimentary knowledge of linear perspective. This can seem very complicated and technical, so it is my intention to focus only on the basic elements and how to apply them to solve some of the problems you may come across. Once the penny drops, it all falls into place and you don't forget it.

Linear perspective works by making objects look further away because they appear smaller. In the front view example below, the house is viewed straight-on, on a flat, level plane. To draw this requires no knowledge of perspective, but it is not very interesting. Note all the parallel dotted lines.

Compare this with the corner view example at the bottom of the page. This shows the same house with the same parallel lines viewed obliquely. Immediately this image becomes more interesting – so what has changed? All the parallel lines now go away from the viewer, leading us into the picture and converging on one or more points called vanishing points.

This effect causes all the vertical lines to diminish as the eye follows them into the scene. A simplified example of this effect, using just one vanishing point, is shown using telegraph poles on a roadside in the example on the opposite page.

Front view

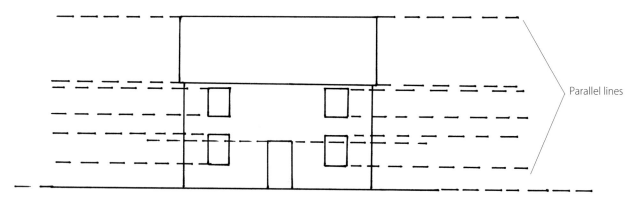

Parallel lines

Corner view

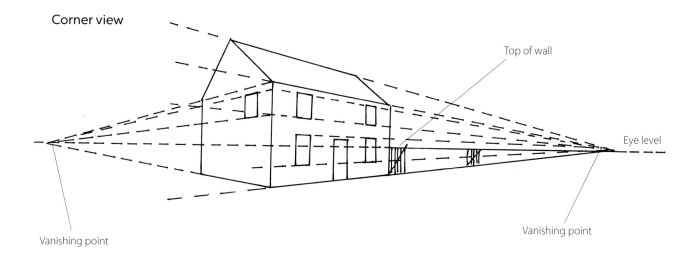

Top of wall

Eye level

Vanishing point

Vanishing point

Eye level and vanishing points

Whether you have one vanishing point or more than one, they will always be on the same level – the horizon or eye level. If you are looking out to sea, the horizon is where the sea meets the sky so it is very easy to see. Most of the time, however, it is obscured by hills, trees, buildings and so forth, so you need to ask yourself, 'Where is the horizon/eye level?' To find this, you need to be aware that all parallel lines below the eye level slope up to it and all those above the eye level slope down to it.

For example, in the corner view of the house (see opposite), the roof top, guttering, upstairs windows and top of the downstairs windows slope down, while the base of the building and bottom of the downstairs windows slope up. As a result, the eye level is somewhere in the downstairs window area, which makes sense when you think about your height in relation to a house.

If you are working outdoors, hold up a ruler or pencil at arm's length between you and the scene, following the parallel lines that slope up and down. The point at which they converge is the vanishing point. Next, imagine a level horizontal line that goes straight through this point from one side of the paper to the other, as shown in the corner view of the house. This is the horizon/eye level. You can then indicate this lightly on your sketch.

Alternatively, look for one of the parallel lines that slopes neither up nor down but runs horizontally across the paper with sloping lines above and below; this will be on your eye level (the top of the wall in the corner view is a good example).

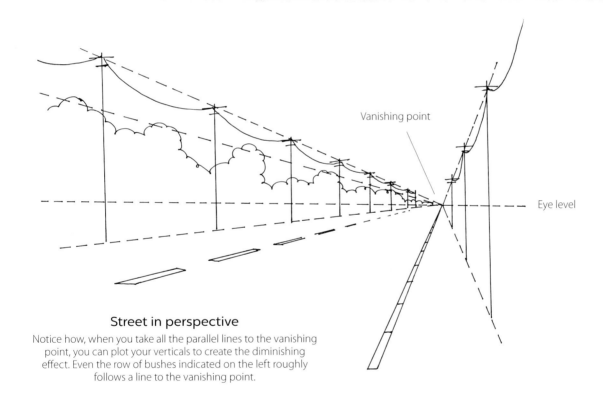

Vanishing point

Eye level

Street in perspective

Notice how, when you take all the parallel lines to the vanishing point, you can plot your verticals to create the diminishing effect. Even the row of bushes indicated on the left roughly follows a line to the vanishing point.

Two-point perspective

The corner view of the building (see opposite), has two sets of parallel lines which each lead to a different vanishing point. This is because, in life, the side wall is at right angles to the front wall, not parallel to it; so you need a second set of lines to help align it correctly. This is called two-point perspective

Though these sets of lines have different vanishing points, they have the same eye level. You can have numerous vanishing points depending on the complexity of the scene, but you can have only one eye level.

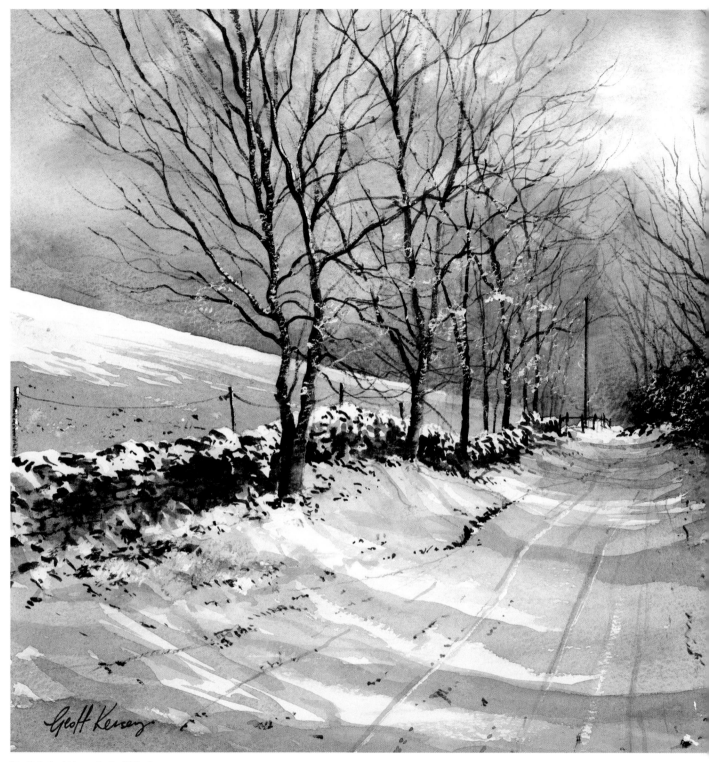

Halldale Woods in Winter

420 x 292mm (16½ x 11½in)

I love to go walking after a fall of snow: it can transform a scene you might not otherwise see as a potential painting subject.

This path leads into a woodland just ten minutes' walk from my home in Derbyshire and has provided me with endless subjects right on my doorstep. Note how, despite this being a winter scene, it doesn't make you feel cold because of the warm glow in the shadows and in the light on the trees.

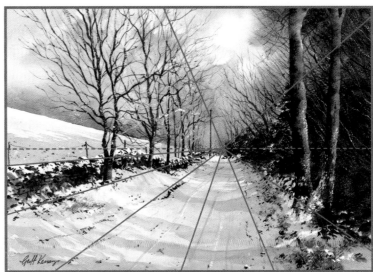

This scene is a good example of how useful linear perspective is in creating a feeling of distance. Most of the main elements – the path, the wall on the left, the bushes and undergrowth on the right, and the trees at both sides – give us parallel lines that lead straight to the vanishing point, which is also the focal point.

Even the slope of the distant field on the right, whilst not a parallel line as such, leads us to the same point. If we look at the diagram above, you can see how this works. Don't be fooled by the dip in the wall due to uneven ground; it recovers its line before reaching the vanishing point. In fact this dip, and other variations like this, are important to the realism of the picture – imagine how rigid and straight the wall would appear without them.

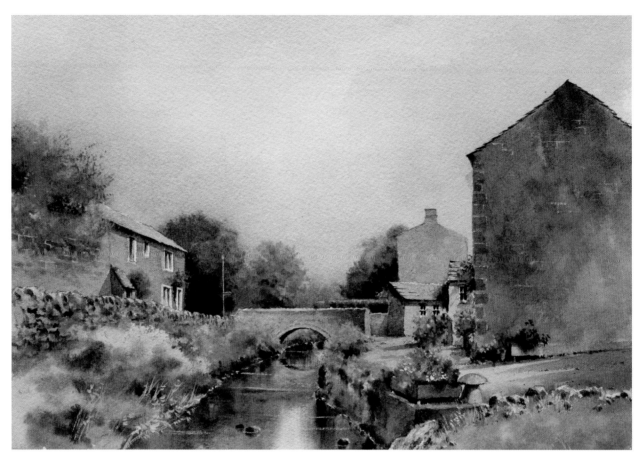

In this scene, the effects of linear perspective are a little less obvious than in *Halldale Woods in Winter* (see pages 26–27), but as you can see in the diagram below, they still play an important part. Note how the left-hand corners of the roofs on the right-hand side create an imaginary line leading the viewer to the vanishing point, the bridge. The bridge is also the focal point in this painting, so lines that reinforce the perspective and lead the eye towards it are important.

Peak Cavern Walk, Castleton
432 x 305mm (17 x 12in)

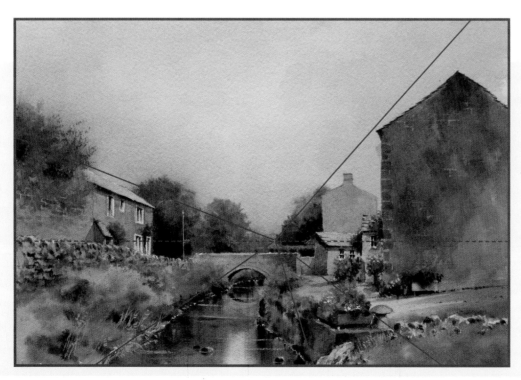

Eye level

Unusual eye levels

Don't be caught out when you view a scene on an incline. The level parallel lines are exactly the same except for the fact that the road itself – which in effect is the bottom of the buildings – will not be parallel with the walls.

In the example below we see a row of buildings on an incline. Note where the eye level is: up in the sky! This is because, although all the parallel lines that make up the shapes of the buildings remain the same, your viewpoint has changed. You are uphill from the scene, so your eye level is above it.

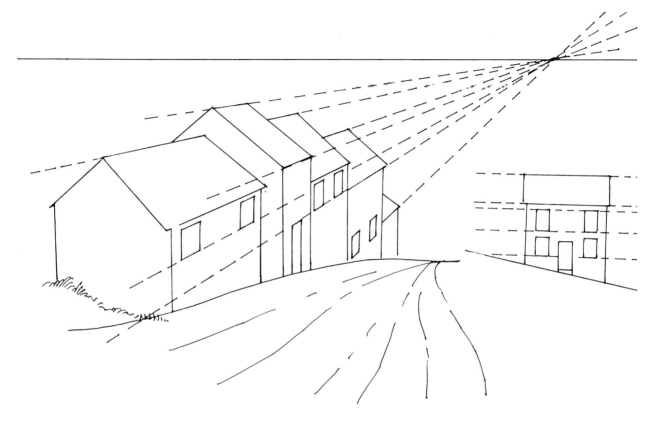

Gable ends in perspective

It is worth considering how to place the point of the gable (see point C in the diagram to the right) as this often baffles the aspiring artist. There is a relatively simple formula to position the end gable: start with the basic off-set square that makes up the side of the building. Put a fine pencil line through each corner, crossing in the centre (point A). Draw a vertical through point A. Gauge the slope of the roof (you can do this by eye) and draw it from point B up to meet the vertical line, at point C. Draw a line from C to the far, top corner of the rectangle, D.

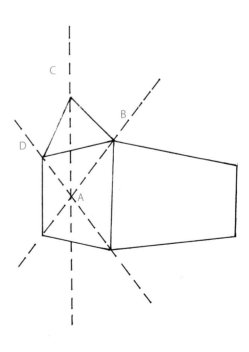

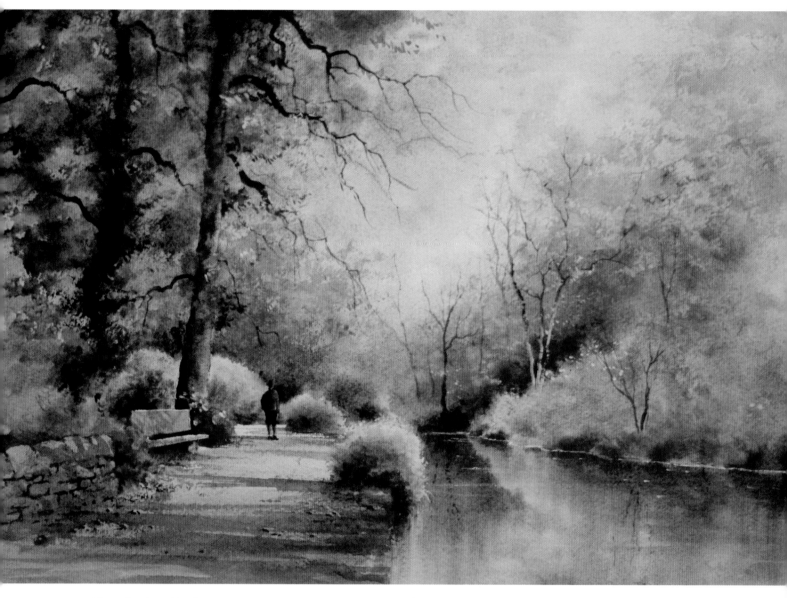

The role played by linear perspective in your paintings does not need to be obvious. In this example, the path, wall, canal and even the bench, all lead us again to the focal point – but more subtly than in the more striking examples on the previous pages.

Don't be fooled by the way the right-hand bank does not follow the perspective lines; there is a widening of the canal at this point, making the left hand line unparallel. This demonstrates that it is important not to slavishly follow theory in your artwork – paying attention to the way the view actually looks will give a more natural effect, even if it seems to contradict the 'rules' of linear perspective.

Summer on Cromford Canal
380 x 280mm (15 x 11in)

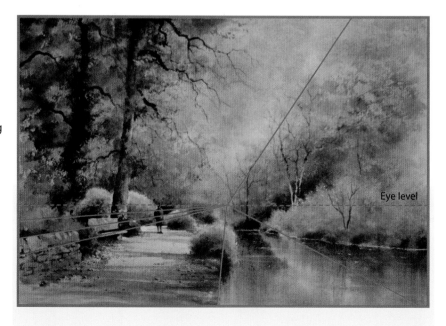

Eye level

Perspective and artistic licence

It is often the case that you find a scene that appeals to you, but it does not contain a natural perspective that will give you the opportunity to create a feeling of distance. An example of this is the simple sketch to the right. This represents a popular location on a canal, where there are two boathouses on opposite banks; they are roughly the same size, and the same distance from the viewer. As artists, we do not have to accept it as it is.

Compare the original composition with the improved version below it. Here, I have taken the right-hand boathouse and enlarged it, creating perspective and bringing it nearer the viewer. This immediately improves the composition as the positioning of the two buildings means that they now complement each other, rather than competing for the viewer's attention. It doesn't matter that it's not as accurate; your objective should always be to create the best interpretation.

Original composition

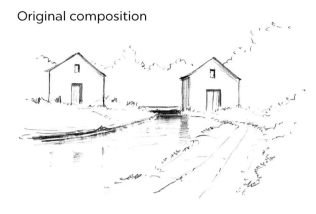

Improved composition

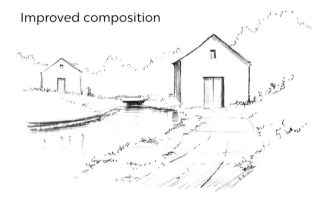

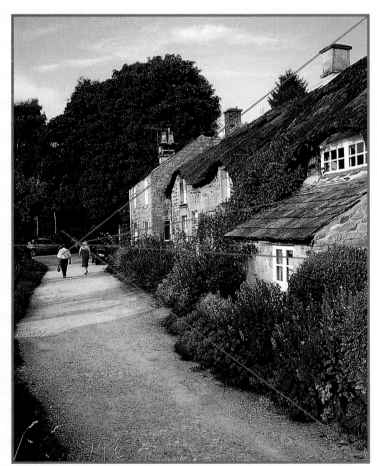

Linear perspective from photographs

If you are working from a photograph, establishing the vanishing point and eye level is simple. Place a ruler along the parallel lines and draw them in lightly (see below). You can easily see where they converge; just rule a horizontal line through this point to establish the eye level.

Eye level

In this example, the eye level (marked by the dotted line) is above the heads of the people walking. This is because I stood on a wall to take the photograph, making my eye level higher than theirs.

Aerial perspective

Having considered how to use linear perspective to create a feeling of distance, we can now look at how to reinforce these principles by means of aerial perspective. Put simply, aerial perspective creates a feeling of distance by observing the effect the atmosphere has on the landscape, making the distance mistier, greyer and altogether less distinct than the foreground. This is a progressive effect; i.e. the further away, the paler and less clear the scene becomes.

 Nature, however, does not always make this easy for us. On a clear, bright morning without a cloud in the sky, the distant colours can be almost as vivid and sharp as the foreground. If we want a painting with such a feeling of depth and distance that the viewer almost feels they could walk into it, we need to interpret what is in front of us rather than just copy it exactly as it appears. After all we could produce an accurate record with a camera.

Use of colour and tone to create depth and distance

We can create aerial perspective by applying some simple principles from our everyday experience to our painting. Some may seem like stating the obvious, but often what we know to be a fact, we don't think of applying to our paintings:

Warm and cool colours
These squares of colour are the same size on a flat piece of paper, but the warm red one has more impact and looks larger and nearer to you than the cool blue one.

- Cool colours (blues and greys) recede, warm colours (reds, browns and yellows) come forward. Use cool colours in the distance, and warmer colours in the foreground.

- Lighter tones look further away than darker ones. Avoid strong contrast in tones in the backgrounds of your paintings.

- When we view a scene, we can make out a great deal of detail in the foreground, but less detail in the distance. Reserve tight, controlled brushwork for the foreground details and keep the background looser.

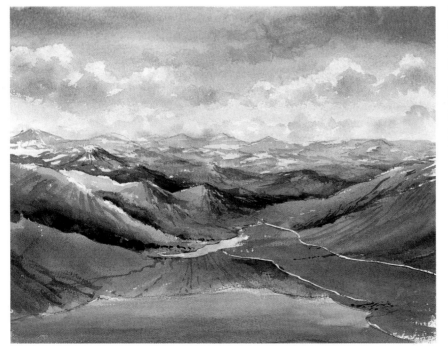

This range of mountains was based on a photograph taken from an aeroplane window. You can see such a long way that it is perfect for illustrating aerial perspective.

 Look at the most distant hills: these are merely suggested with a pale blue wash using the same colour as the sky. Warmer colours and stronger tones are very gradually introduced as we come further forwards in the painting.

The effects of aerial perspective

Look at the two paintings to the right. There's no doubt that the one at the top looks like what it is supposed to be; green hills and pastures with a crisscrossing of dry stone walls and trees under a blue sky. However, compare it with the painting below it. It is the same scene, but what a difference it makes when we apply some methods to create aerial perspective.

First of all, note how the sky is darker in tone at the top and lighter towards the skyline. Despite the fact that the distant hills on the source photograph were green, I have painted them in a pale blue-grey, with the furthest hill indicated with the palest wash. Light and atmosphere have been injected into the scene – the area in the centre is bright, while the tones gradually get stronger and colours darker towards the foreground.

Note how the distant trees are painted in softer, mistier shapes, becoming more clearly defined nearer the foreground. To emphasise this effect a hint of brown (a warmer colour) has been added to the nearer trees. Finally a few touches of detail – grasses, foliage and so forth – have been added to the foreground. Remember that the nearer you are to something, the more detail you see.

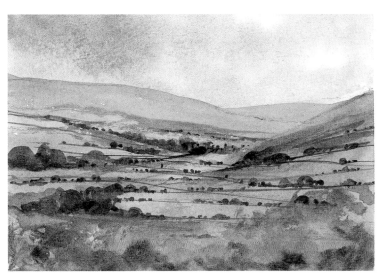

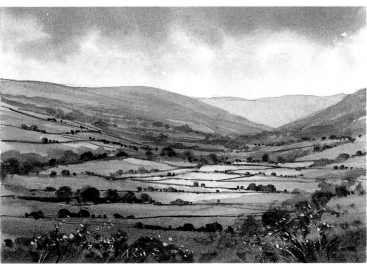

Combining aerial and linear perspective

In this scene, both linear and aerial perspective have been used to create a feeling of depth and distance.

Linear perspective has been used to take the lane right into the distance. All the lines created by the tops of the hedges, the bottoms of the hedges and edges of the track converge on the eye level in the distance.

Aerial perspective is also employed: the trees gradually become smaller, less detailed and cooler in colour as they recede into the scene, and the background foliage on the horizon is picked out in subtle blue-greys.

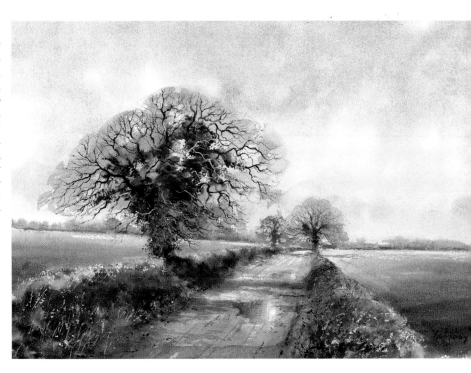

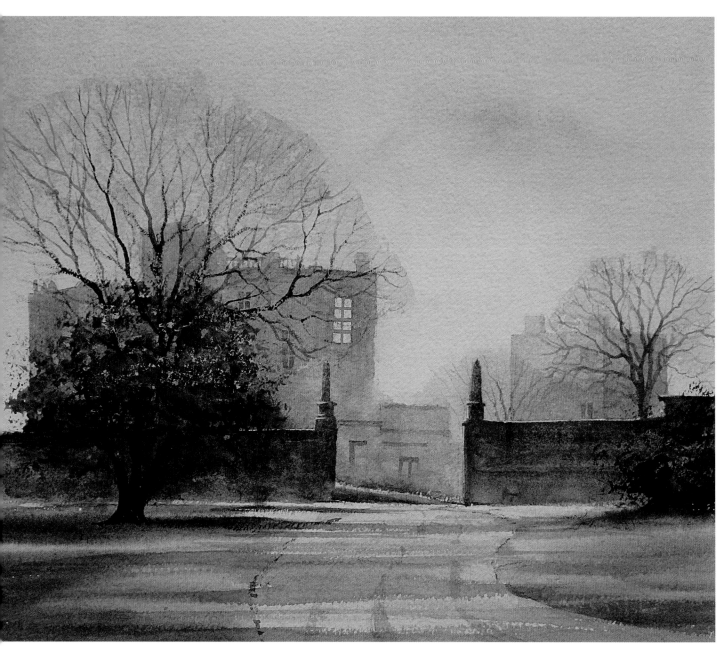

When you compare the cool colour and light tone of the ruins in this scene with the warmer, stronger tones of the wall and tree in the middle distance, you can see how this creates an impression of distance. This is further strengthened by the sunlit grass and path in the foreground, which are brighter and stronger toned.

I began this painting by creating a bright glow in the lower part of the sky. A heavier blue-grey was added at the top for contrast and a vital hint of warmth was added using a touch of light red. I then mixed the light red with the blue grey to create a slightly warmer grey for the misty shapes of the distant ruin; still keeping the colour light.

Old Hardwick Hall

430 x 330mm (17 x 13in)
The gap in the wall created by the open gateway is a vital part of the composition as it invites us in.

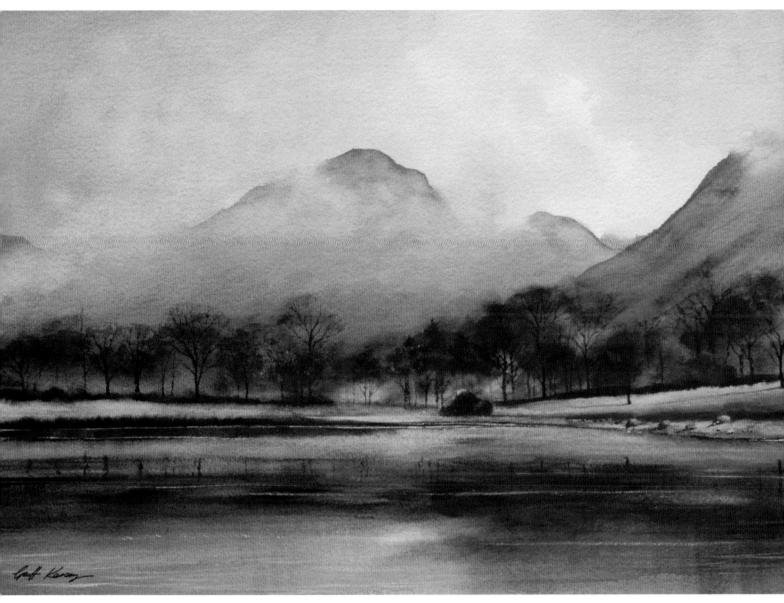

The cool blue-grey colours in the sky here are deliberately echoed in the distant mountains. Note how the mountain on the right is still basically grey but has been painted with a slightly stronger tone to bring it further forward. The warm autumnal brown and orange shades are reserved for the nearer slopes of the right-hand hill and the fields and trees in the middle distance. The mist on the distant hills is also a very useful device as misty, indistinct objects will always look further away.

Autumn evening on Derwentwater
480 x 305mm (19 x 12in)

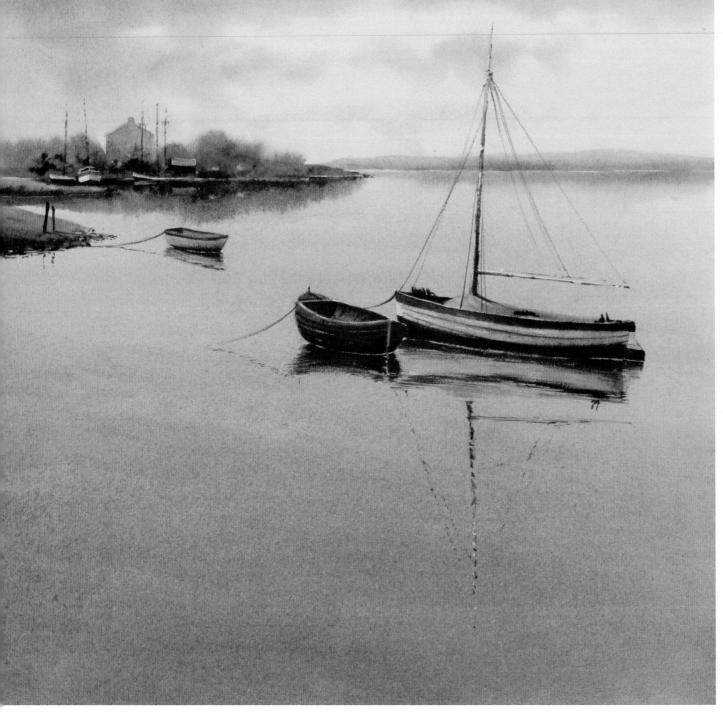

As soon as I saw this calm, tranquil scene I knew it would make a great subject for a painting. As the colours for much of the scene are quite low-key and muted, the importance of aerial perspective is not immediately obvious, but if we examine the scene more closely, we can see how the suggestion of a strip of land at the furthest point in the scene is a very light, cool grey. Compare this with the warmer, stronger tones reflected in the water in the foreground. The left-hand bit of land – nearer than the furthest strip yet still in the distance – has been painted in a slightly stronger, warmer grey, but retains a soft, slightly misty look to keep it in the distance.

Other elements that help create a feeling of distance in this scene include the way I have used crisper shapes and stronger colours for the foreground boats, and incorporated cerulean blue for the tarpaulin and French ultramarine for the hull of the larger boat. These colours contrast well with the muted greys and browns. There is also a subtle element of linear perspective, with the smaller boat shape and peninsula of land in the middle distance, leading us into the scene.

Evening light, Burnham Overy Staithe
406 x 381mm (16 x 15in)

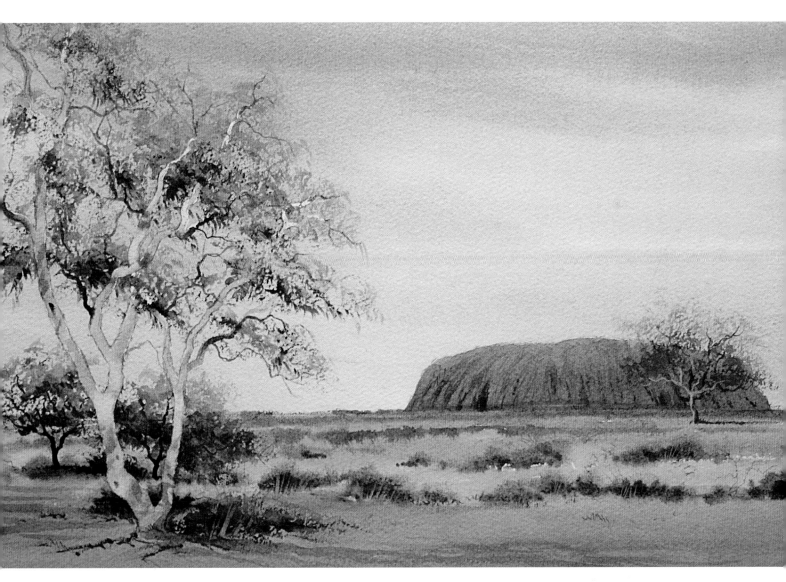

How to apply aerial perspective to the subject above is less obvious. You just can't get away from the fact that Ayers Rock (Uluru) is red – if it were depicted in blue-grey, it wouldn't be the same place. The problem this creates in this scene is that the rock is very much in the distance and, as we have already established, red is a warm colour that makes objects appear nearer.

I have muted the red slightly in this painting, but in order to keep some of the essential warmth to the colour, I relied mainly on other artistic devices to create the correct feeling of distance. I painted the sky considerably lighter nearer the horizon, and made it stronger and darker towards the top. The large tree in the left-hand foreground is a lot larger and contains more detail than the much smaller tree in the distance on the right. This sense of diminishing shapes is further reinforced by the dry, scrubby bushes and grasses at ground level, which gradually reduce in size as we look into the distance. I have also used a sandy yellow colour for the middle distance ground, and reserved the warmer red for the foreground.

Ayers Rock
458 x 305mm (18 x 12in)

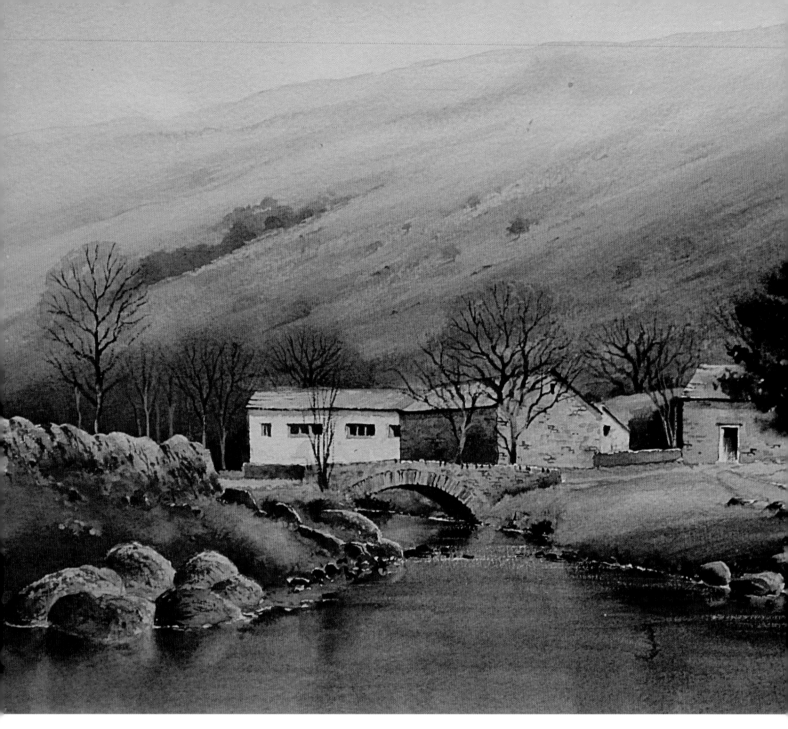

Aerial perspective and artistic licence

Your source photographs will not always show the effects of aerial perspective. In these cases, you will have to use some imagination and interpretation to avoid your painting looking flat.

If we look at the source photographs used for this scene (see opposite), we see that the background hill is a warm vivid orange, due mainly to the autumn bracken upon its surface. I like this colour – preferring it to green, in fact – but if we take the photograph too literally, the warmth of this colour will come forward, rather than receding into the distance. Compare the photograph with the finished painting and you can see how I have rendered the top of the hill (which is the most distant part of the scene) with light mixtures of blue and grey. These colours tone in with the glimpse of sky and blend very gradually into the warmer colours as we come down into the lower slopes.

Observe how the suggestions of distant trees on the hillside are also rendered in cool grey in a very light tone. Note too how I have used contrasting light and dark tones in the middle distance, where the buildings are, to draw attention to these, which also helps to draw the viewer into the scene.

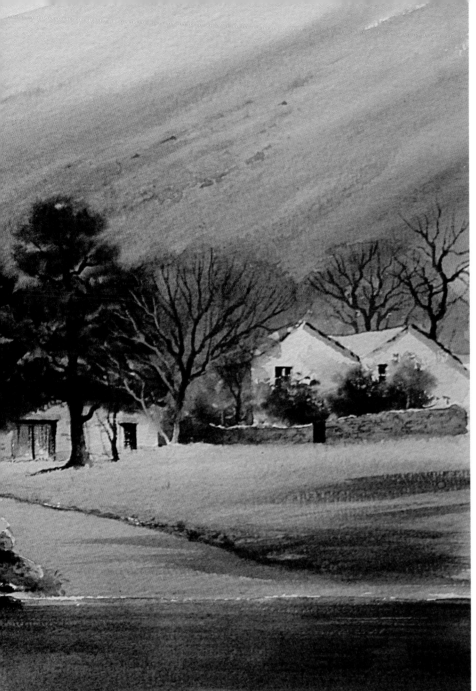

Watendlath Beck, Cumbria
560 x 280mm (22 x 11in)

I used sticky tape to join two source photographs together to create the panoramic format.

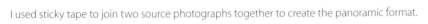

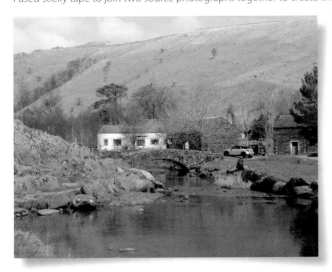
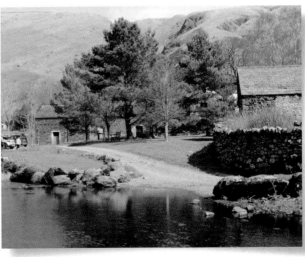

 # Skies

Beach Huts at Minehead
340 x 270mm (13½ x 10½in)

I believe that in most landscape paintings, whatever the medium, the sky is the most important element, as it sets the whole mood and atmosphere for the scene. Get the sky wrong and it is difficult to make a success of the painting; paint a good sky, however, and you are on your way, enthusiastic and motivated by the promising start.

The key to painting successful skies is preparation. This means taking the time to think about what you want the finished sky to look like, deciding which colours you intend to use and mixing all the initial washes before you put brush to paper.

When you are ready to commence, try to limit the time you spend painting the sky to thirty to forty seconds for each stage. I have seen more skies ruined by overworking than any other fault. Remember also that the glow in a watercolour depends on the light penetrating the transparent washes and reflecting off the paper, and the more you keep swirling the paint around, the greyer and more dense it becomes.

Here are seven different sky painting methods that are well worth trying. Paint them quite small at first, maybe filling a large sheet with numerous postcard size examples until you become more confident.

A wet in wet sky with three washes

This method of painting a sky, which conveys a diffused softness, is the one I use more frequently than any other. I prefer to mix grey rather than use it straight from a tube, as I believe the variations are infinite. For instance, adding a touch more cobalt violet to the mix described below would make a warmer grey, and a touch more cobalt blue a cooler grey.

1 Wet the paper over the whole sky area with a 2.5cm (1in) flat brush, and mix three washes: Naples yellow with burnt sienna, cobalt blue with cobalt violet, then the same again with burnt sienna added. I painted this sky with a large filbert wash brush.

2 Paint Naples yellow and burnt sienna across the lower part of the sky, then the cobalt blue and cobalt violet across the top, followed by the third mixture across the very top and a few dashes across the middle to represent hazy cloud shadow. Try to paint rapidly, then leave it alone.

3 The finished sky. When dry this will look quite different from when it was wet; the colours should have gently fused into one another, going slightly paler and creating a soft diffused look.

The soft, diffused shapes create a gentle effect and the slightly milky colour is ideal for portraying winter afternoon light.

Don't judge your work while it is still wet – walk away from it and you'll be pleasantly surprised by the magic that takes place on the paper in your absence.

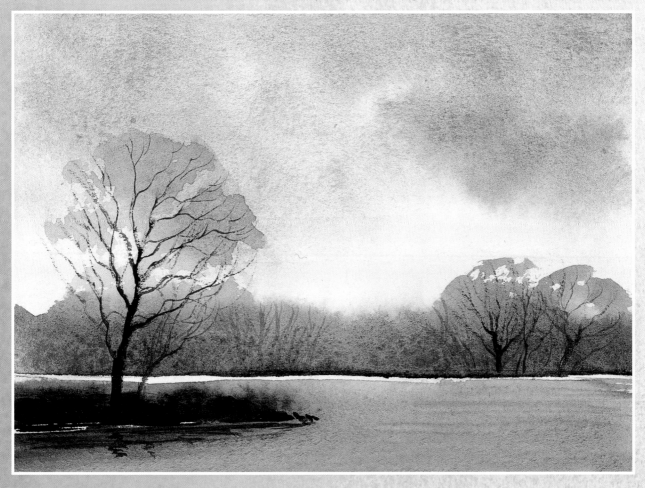

Dabbing out clouds

This is not a method I use very often, preferring to leave the white rather than dab it out. However, this technique can be effective and is certainly fun to try.

1 Mix two washes: cerulean blue for a cool colour near the horizon and cobalt blue with cobalt violet for a warmer blue at the top. Wet the paper with a flat brush, then using the same flat brush apply the washes with smooth horizontal strokes. Wetting the paper allows you more time before the washes dry. Dab out cloud shapes using a piece of kitchen towel. Scrunch up the kitchen towel to make smaller clouds lower down.

2 You can leave the clouds as they are, or add shadows. Wet each cloud individually with clean water and immediately drop in a grey created with cobalt violet and cerulean blue.

3 The finished sky.

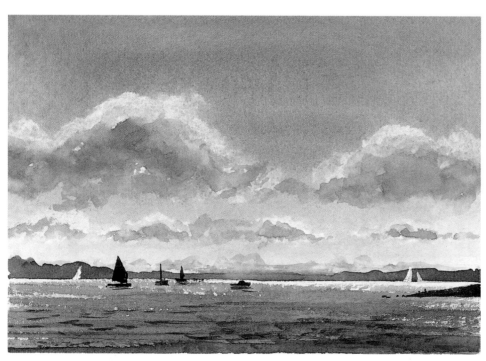

It is very important with this example to make each subsequent row of clouds smaller as it gets nearer to the horizon. This creates that all-important feeling of distance and is what we mean by aerial perspective (pages 32–33).

Lifting streaks with a brush

This can be a very effective technique for finer clouds, but you need to work quickly as once the paint has started to dry, it will not lift out. It is also important not to have the angle of the brush strokes too steep.

1 Mix two washes: cobalt blue and French ultramarine and a thinner wash of cobalt blue. Wet the whole page with clean water. Apply the first wash at the top, bringing it two-thirds of the way down the paper, using the flat brush. Then change to the second wash so that the sky is cooler towards the horizon. Wash and dry the brush immediately until it is just damp and use it to lift colour out.

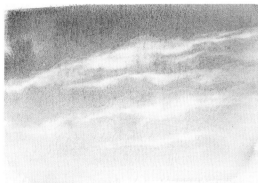

2 Keep cleaning and drying the brush to keep it 'thirsty'. Twist and turn the brush across the paper to make cloudy streaks, sloping them slightly uphill. Allow to dry.

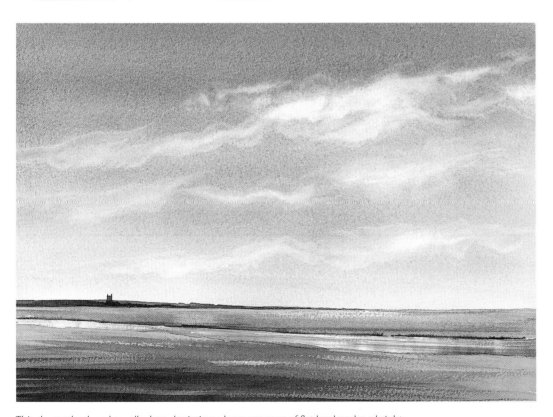

This sky method works well when depicting a large expanse of flat land under a bright summer sky. The window for lifting out the streaks of colour is very small so you need to be well prepared and work quickly. The twisting motion of the brush helps to make the streaks look like cirrus clouds; if you don't twist and turn it enough, they are much less convincing.

A sunset sky

It is great fun to paint sunset skies. Try them with beach or coastal scenes where the sky can be reflected in the land.

1 Mix three washes: a thin wash of lemon yellow; raw sienna with light red to make orange and cobalt blue with rose madder to make purple. Wet the background with a flat wash brush and clean water. Then drop in the washes from the bottom upwards: lemon yellow, then the orange in the middle, then bluey purple at the top.

2 Working quickly so the background is still wet, drop in cloud shapes using a no. 16 round brush and a mix of cobalt blue, rose madder and light red. This mix should be slightly thicker than the previous washes so that it spreads slowly into them. Make the clouds larger at the top and smaller nearer the horizon, again to help with that feeling of distance.

3 The effects of this wet in wet technique will carry on changing as the loose cloud shapes soften into the previous washes until the painting is dry.

With a sky like this one you cannot make out much detail on the land as everything is reduced to silhouettes. These dark shapes can be made up of stronger versions of the colours used in the sky so the whole scene has harmony – the benefit of the limited palette.

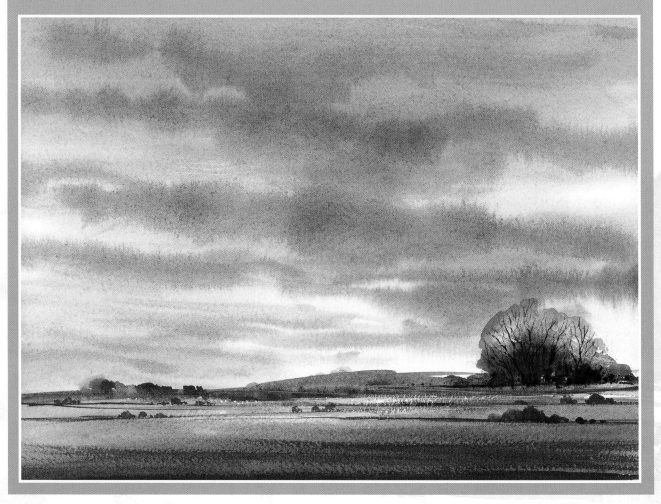

Four washes on a wet background

For this technique, it is very important to work quickly so as to avoid unsightly run-backs (also known as cauliflowers). You need to mix plenty of paint in advance, because vital time can be lost if you have to stop to mix more.

1 First mix four thin washes: raw sienna, cobalt blue, neutral tint and sepia. Wet the paper with a sponge and with a filbert wash brush, apply a thin wash of raw sienna in the lower sky with the side of the brush. Clean the brush, then wash on cobalt blue at the top, leaving some white paper. Add a wash of neutral tint at the top and bottom.

2 Paint on sepia at the top of the sky to darken it. Slope the board to allow the washes to spread into each other; do not work them with the brush for long as this will mix the raw sienna and cobalt blue, creating a grey-green. Do not judge the sky while it is wet, because it will lighten as it dries.

This combination of strong colours creates a dramatic effect, which can depict approaching bad weather and look very atmospheric. You have to be careful, however, to float the colours in and leave them to work their magic, as the more you swirl them about the more you are in danger of blotting out the light area in the centre, which you can use to great effect to illuminate the land.

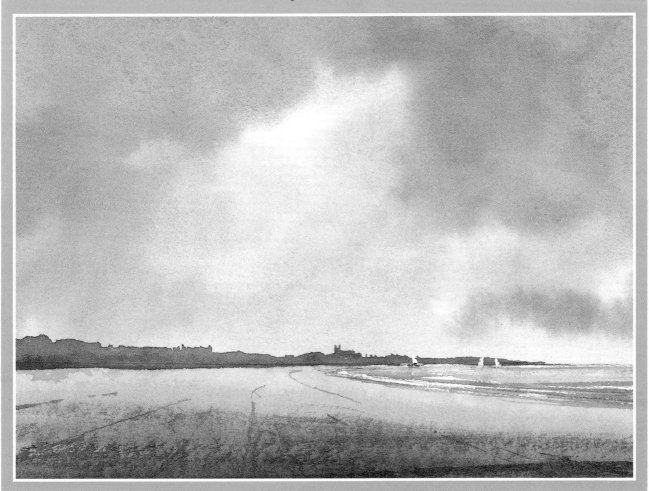

A glazed sky that is lighter at the top

This approach to painting a sky can be particularly effective to add drama to a large expanse of sky.

1 Unlike the previous skies which are lighter at the horizon and darker towards the top, this one is reversed. Mix three separate glazes: cadmium red, cobalt blue and neutral tint. They should all be quite thin so that they will be transparent. Apply the first wash of cadmium red with a no. 16 brush from the horizon line, thinning it towards the top with water so that it fades out to white. Leave the painting to dry completely.

2 Repeat this procedure with the cobalt blue, again softening with water towards the top. Allow to dry completely.

3 Repeat once again with the final glaze of neutral tint.

4 The sky when completely dry.

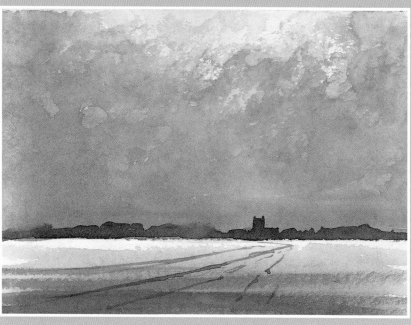

This type of sky is very useful for snow scenes or ploughed stubble fields where you can achieve a sharp contrast at the horizon with the dark of the sky against the brightly illuminated land.

Separate glazes

Also good for a large dramatic skies, this technique relies on the paint drying thoroughly between each application.

1 Using a no. 16 round brush, wet the top right-hand side of the painting only. Wash in cobalt blue across the top of the whole painting and cerulean blue lower down. Soften with clear water to avoid any hard edges. Allow the painting to dry completely, so that later work will not disturb these washes.

2 Lay in grey cloud on the dry paper using a wash of neutral tint with just a touch of rose madder. Soften a few of the cloud edges with a damp, but not wet, clean brush. Don't soften all the cloud shapes as it is more interesting to have variation, with some hard and some soft edges. Leave this to dry.

3 Using the same mix of neutral tint and rose madder, add some dark cloud to the top left of the scene, again softening in places with a clean, damp brush.

As there are three glazes on this sky, it is important that each one is quite thin and transparent so that with each subsequent glaze you can glimpse the previous one underneath.

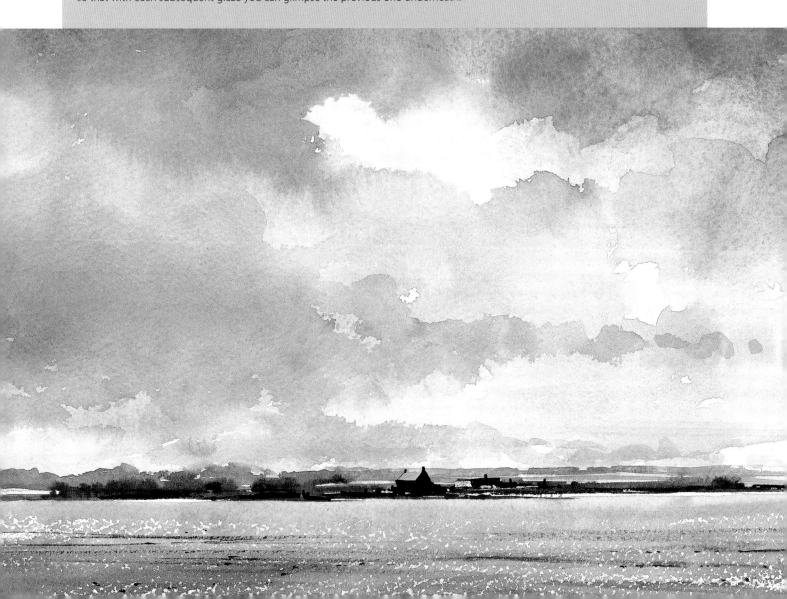

Snow Scene

The first few days of the year often give some marvellous weather conditions for gathering painting subjects. On this wintery day, there was a light coating of snow under crisp, bright, clear skies and I knew this scene was a painting as soon as I came across it, on a woodland walk in the Peak District.

I find that nature does not often give us a perfect composition, but I think this is one occasion where all the main aspects of the scene are perfectly placed. Our eye is led from the large silver birches on the left, along the winding path to the smaller birches and out into the distance, where we get a glimpse of the hills beyond the woods.

YOU WILL NEED
Rough paper, 380 x 300mm (15 x 11¾in)
Masking fluid
Naples yellow
Cobalt blue
Cobalt violet
Burnt sienna
Raw sienna
French ultramarine
White gouache
Old paintbrush
2.5cm (1in) flat wash brush
Large filbert wash brush
Round brushes: no. 12, no. 4, no. 16, no. 8, rigger
Craft knife

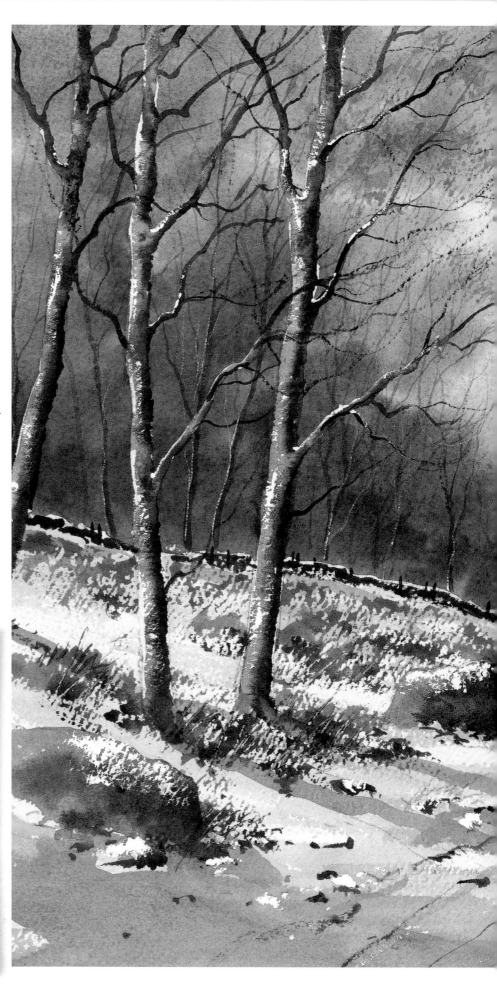

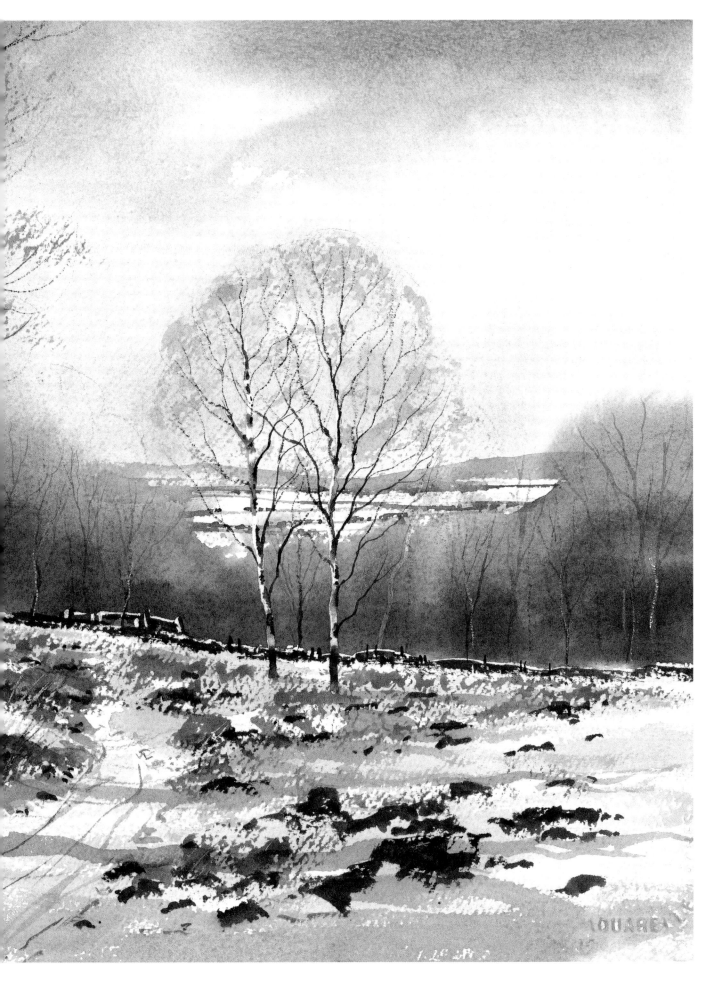

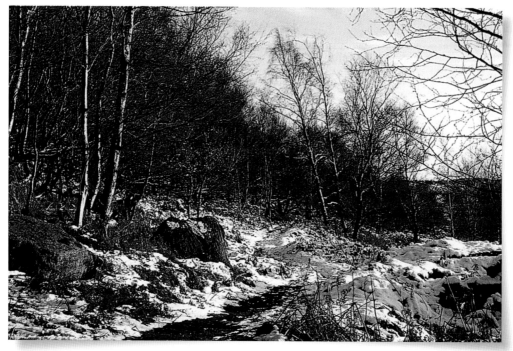

Source photograph

When I came across this scene on a New Year's Day walk in the Peak District, I knew instantly that it was a ready-made painting, and I couldn't wait to get back to the studio to get cracking. I was attracted to the way there is just the hint of a path snaking its way through the snow-covered ground, which is itself strewn with boulders and dead bracken. In the painting I have revealed this path a little more, but it ultimately remains just a suggestion, with the route picked out using a few snow shadows and bits of vegetation.

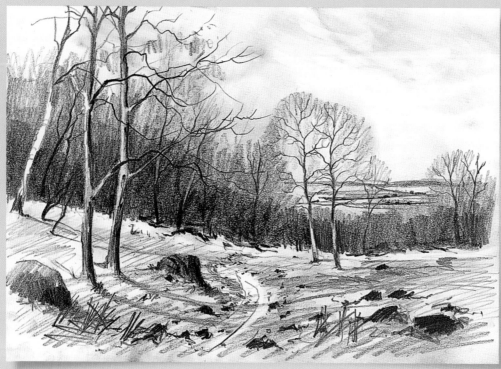

Preliminary sketch

A quick pencil sketch like this helps to identify the basic elements and simplify the scene. I have used the sketch to bring out the way the taller trees on the left of the foreground frame the scene, and lead the viewer's eye to the shorter trees in the middle distance. The rocks and boulders – larger in the foreground and diminishing in size as we go into the scene – are also useful to help emphasise the perspective. It is almost always a good idea to include devices like this as they provide perspective without appearing contrived.

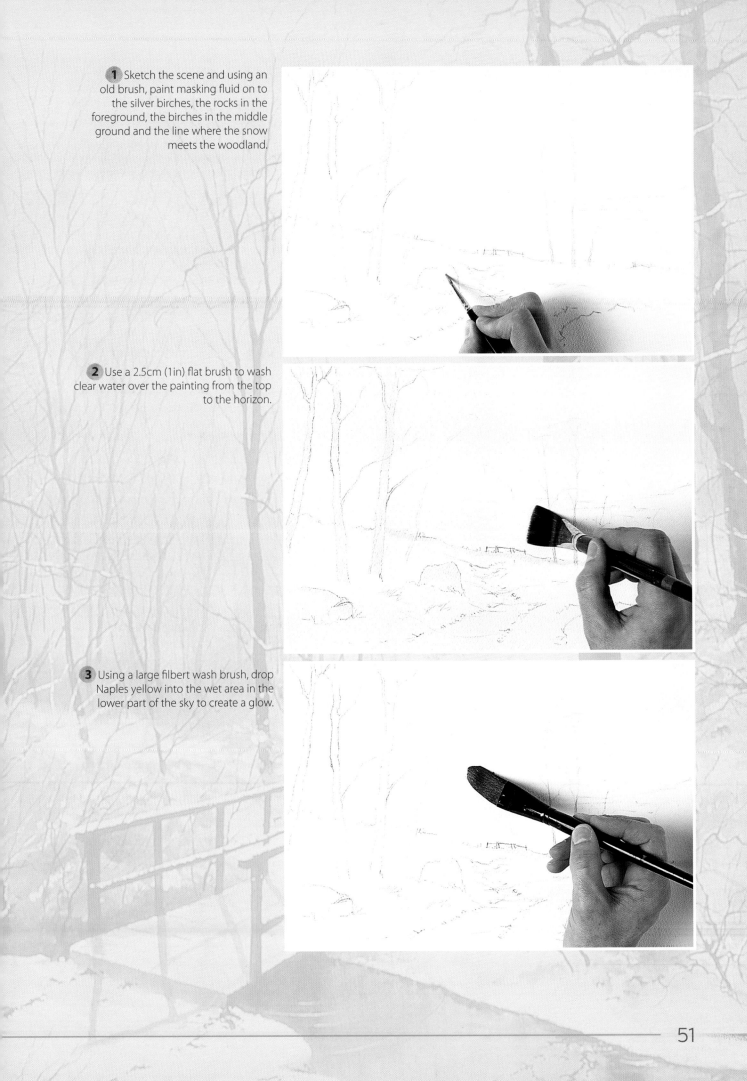

1 Sketch the scene and using an old brush, paint masking fluid on to the silver birches, the rocks in the foreground, the birches in the middle ground and the line where the snow meets the woodland.

2 Use a 2.5cm (1in) flat brush to wash clear water over the painting from the top to the horizon.

3 Using a large filbert wash brush, drop Naples yellow into the wet area in the lower part of the sky to create a glow.

4 While the paper is still wet, drop cobalt blue and cobalt violet in at the top of the painting, down to about half way. The sky should be darker at the top, which gives the impression of perspective. Leave areas of white paper to suggest clouds. Add burnt sienna to the previous mix for a cloudy grey and drop this in.

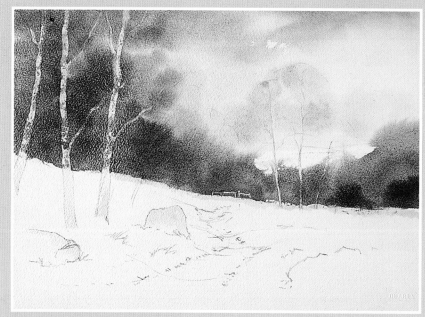

5 Drop in a thick mix of cobalt blue, cobalt violet and burnt sienna for the tree area. Use the side of the brush to suggest soft edges at the tops of the trees. Add raw sienna and burnt sienna for a red glow.

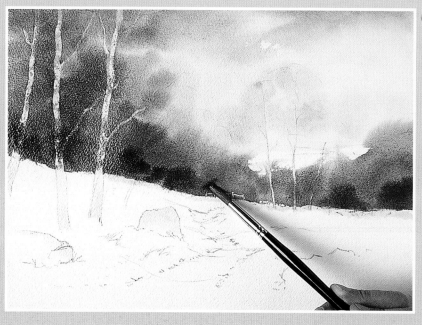

6 Working wet in wet, add cobalt blue and burnt sienna for the darker area at the bottom of the trees. Allow the painting to dry.

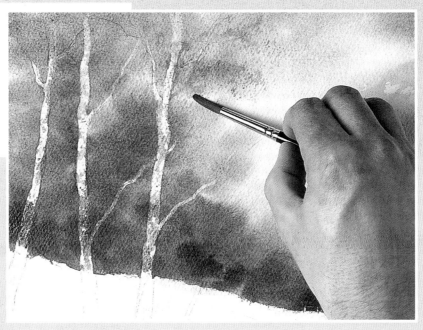

TIP

For dry brush work, hold the brush on its side with four fingers on one side and the thumb on the other so the side of the hairs just catches the raised area of the Rough paper.

7 Use the side of a no. 12 round brush and the dry brush work technique to suggest the finer foliage at the ends of branches.

8 Mix cobalt blue, cobalt violet and burnt sienna, the colours that made up the grey and blue of the sky. With the no. 12 round brush, paint in the distant hills, wet on dry. The cool colours will make the hills recede into the background.

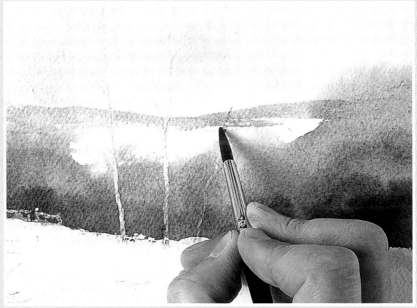

9 Using the same colour mix and the very tip of the no. 12 brush, suggest the distant trees and dry stone walls. Use a little bit of dry brush work to emphasise the tops of the trees in the middle distance with raw sienna and burnt sienna.

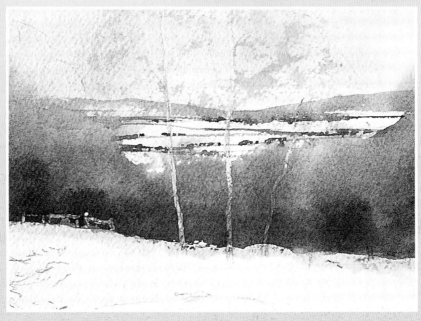

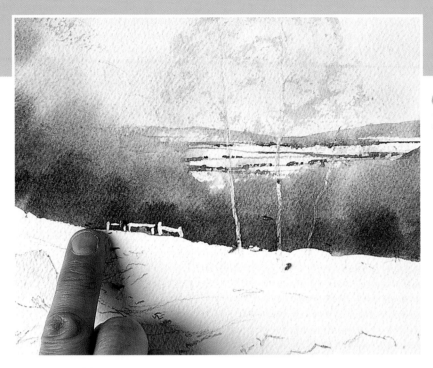

10 Rub off the masking fluid at the base of the tree line using a finger. Clean up with a putty eraser if necessary.

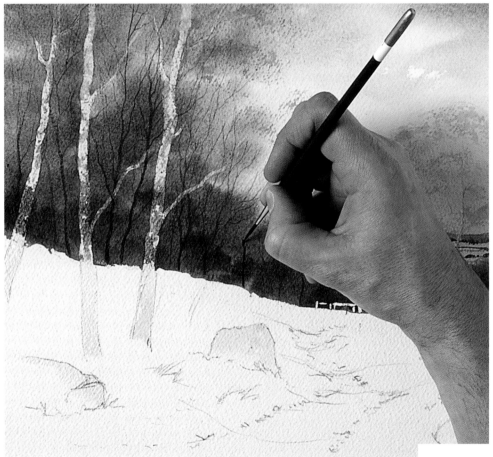

11 Mix a brown using cobalt blue mixed with burnt sienna, and with a no. 4 round brush, paint in distant tree trunks. Make some look further away by adding more water to the mix, and some nearer by using thicker paint. Use a rigger brush for finer branches.

TIP

Rapid strokes of the brush look more convincing when painting trees in the distance. Always paint trunks and branches from the bottom upwards.

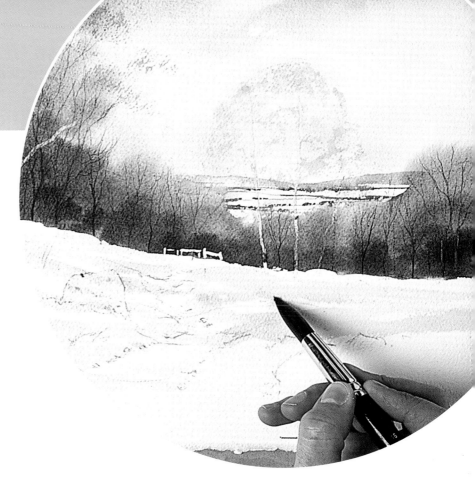

12 Mix the sky colours cobalt blue and cobalt violet for the snow shadows. Wash them on using a no.16 round brush, taking care to leave some of the paper snow-white. Your brush strokes should follow the contour of the land. Dampen the paper for softer areas. Use a weaker wash in the middle distance, and begin to pick out the shape of the path.

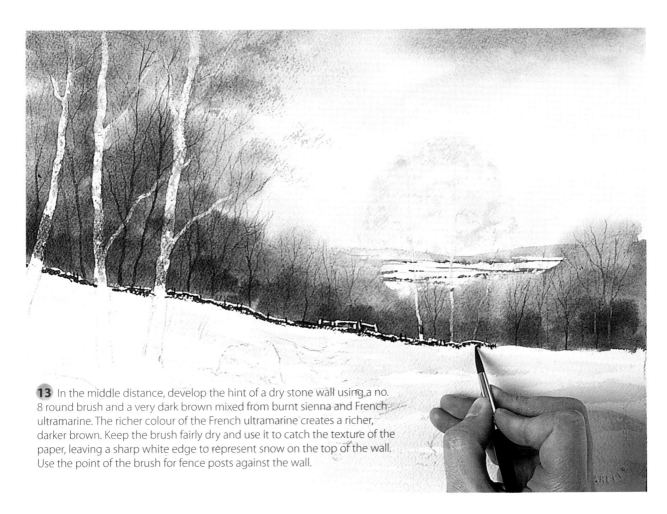

13 In the middle distance, develop the hint of a dry stone wall using a no. 8 round brush and a very dark brown mixed from burnt sienna and French ultramarine. The richer colour of the French ultramarine creates a richer, darker brown. Keep the brush fairly dry and use it to catch the texture of the paper, leaving a sharp white edge to represent snow on the top of the wall. Use the point of the brush for fence posts against the wall.

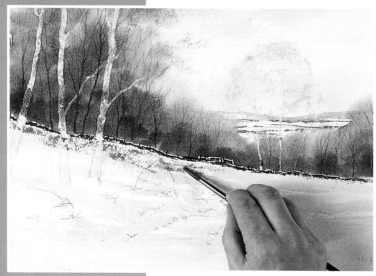

14 Make a thick mix of raw sienna and burnt sienna and use the side of a no. 8 round brush to catch the paper texture to indicate bracken in the snow.

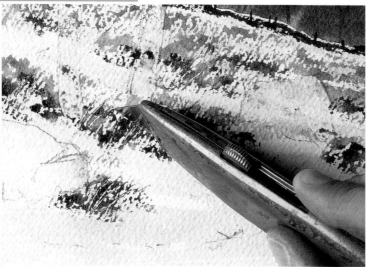

15 Drop dark brown in to the red bracken while it is wet. The effect will be soft where the paint is wet and scumbled where it meets the dry paper. Scratch out the shapes of grasses and twigs using a craft knife.

 TIP

The scratching out technique depends on good timing. If you scratch out when the paint is too wet, colour runs back in to the grooves; if you leave it too late, the dry paint will not scratch out. The best time is when the shine has just gone from the paint.

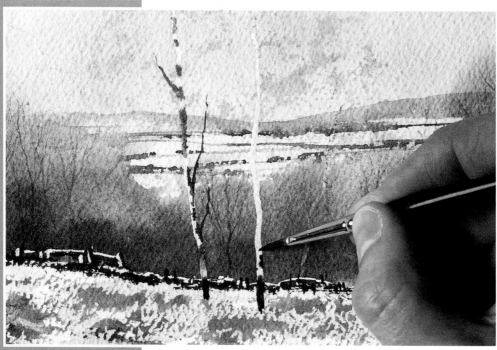

16 Rub off the masking fluid from the middle trees. Wet the trunks with clear water and drop in dark brown using a no. 4 round brush. The paint will spread into the wet area. To bring these trees forwards, the darks on their trunks should be darker than the background and the lights lighter.

17 Take a rigger brush and indicate the finer details of the branchwork.

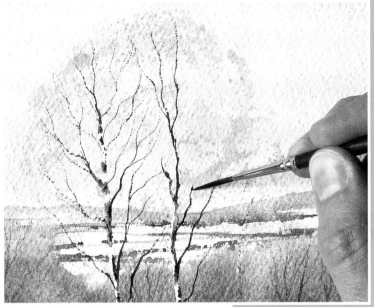

18 Rub the masking fluid from the foreground trees. Wet the right-hand trunk and drop in a mix of Naples yellow and raw sienna. Working wet in wet to avoid stripes, drop in a mix of cobalt blue and cobalt violet, then add a dark brown mixed from burnt sienna and French ultramarine on the right-hand side, since the light is coming from the left. Paint the finer branches in the same way using a rigger brush.

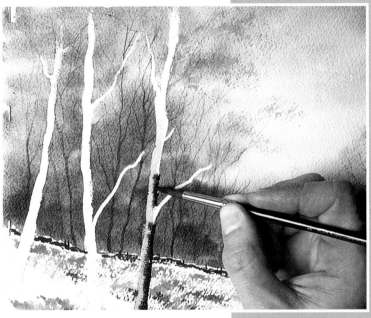

19 Work the remaining two foreground trees in the same way.

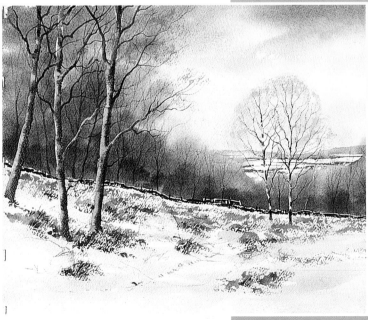

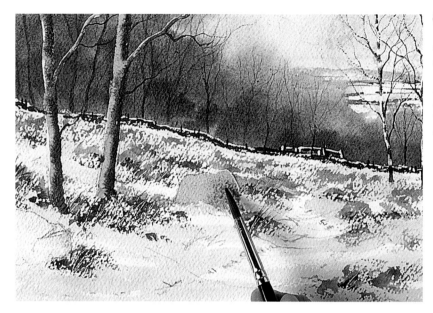

20 Rub the masking fluid off the large rock. Mix raw and burnt sienna plus a green from raw sienna and cobalt blue, and for the darker areas of stone mix burnt sienna and French ultramarine. For shadow use the sky colours, cobalt blue and cobalt violet. Mix all these colours wet in wet on the rock, leaving white for a hint of snow.

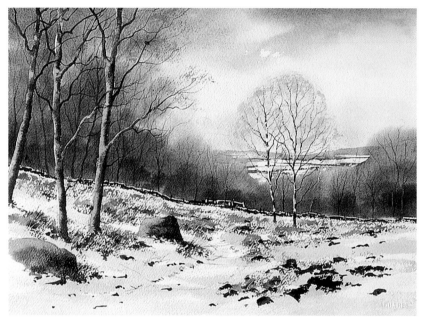

21 Paint the other rock in the same way. Use a no. 8 brush and dark brown to suggest stones sticking up through the snow. Make these larger nearer the foreground to help the perspective.

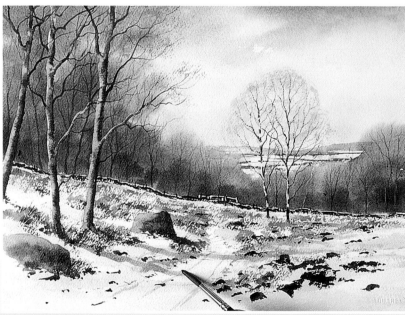

22 Paint the shadows in cobalt blue and cobalt violet. It is important that the paint is transparent so that the colours underneath show through. Put in long shadows for the left-hand trees to emphasise the direction of the light.

23 Paint in shadows to suggest trees beyond the left-hand edge of the picture casting shadows into the scene, and indicate the ruts in the path to create linear perspective. Make your marks stronger near the foreground, which creates aerial perspective. Take a no. 16 round brush and add more of the same colour to bring the foreground forwards. Soften any hard edges with a damp, clean brush.

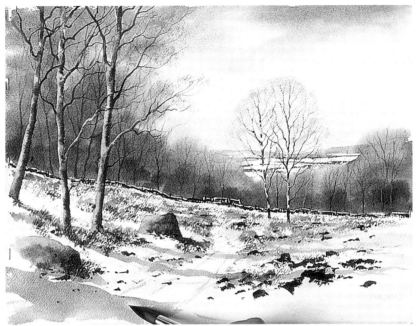

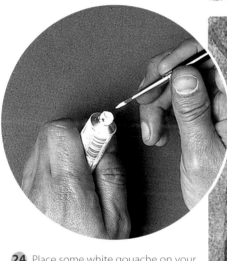

24 Place some white gouache on your board or use it straight from the tube. Do not put it in your palette, or it will make the other colours chalky. When the watercolours are dry, pick out snowy details on the trees using the white gouache and a no. 1 brush. Do not dilute the gouache as it will become less opaque and appear less white.

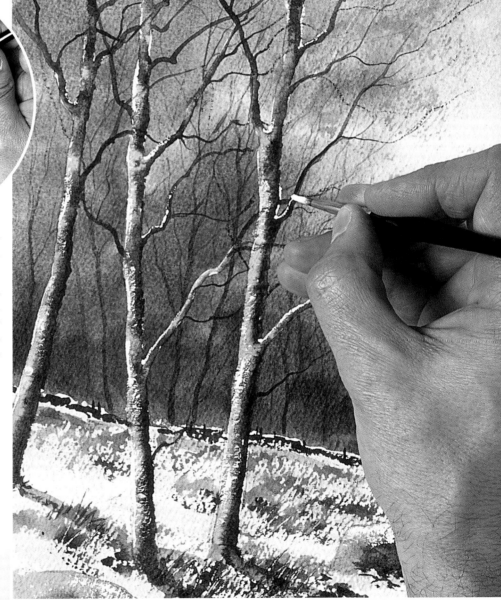

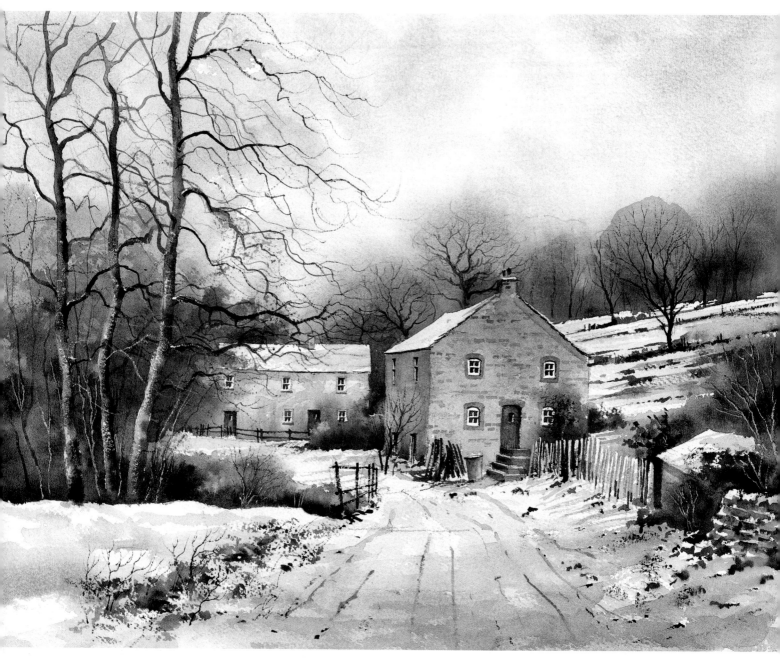

Winter in Padley

355 x 265mm (14 x 10½in)

This is one of my favourite areas in the Peak District; I must have painted here dozens of times. The main blue in the sky and in the shadows is cerulean; this is quite a cold colour and really injects a wintery feel into the scene, especially when combined with the milky sunlight effect in the lower part of the sky, suggested with a thin wash of Naples yellow. Note how the shadows have been indicated with the same cold blue, warming it slightly with a touch of rose madder in the foreground to bring it forward.

Opposite:

Foot Bridge in the Woods

530 x 750mm (21 x 29¾in)

This is a little hidden location twenty minutes' walk from my home. The light was perfect on this cold winter's afternoon with that beautiful red glow, which I recreated with thin washes of Indian yellow and cadmium red. Note the aerial perspective created by rendering the more distant trees in cooler colours and lighter tones.

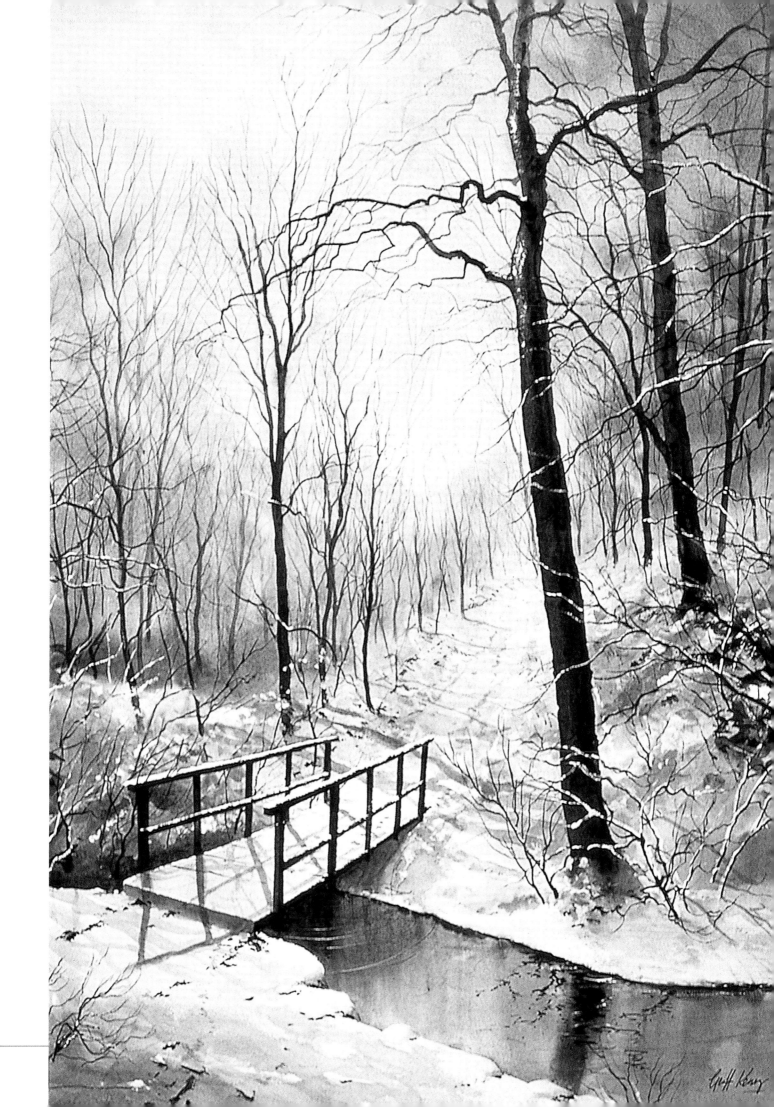

Glencoe

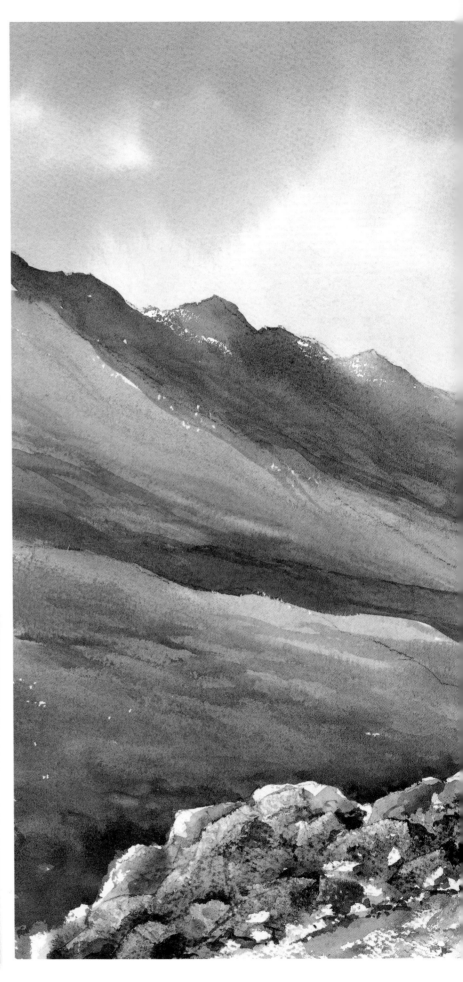

This atmospheric scene from the Highlands of Scotland is a good illustration of how to combine aerial and linear perspective to create a feeling of distance in a painting.

The linear perspective is simply the path of the river winding into the composition. Note that it disappears out of view, leading your eye to the focal point to the right of the centre. Had this been dead centre it would have ruined the composition, dividing the paper down the middle. The aerial perspective is created by making the left-hand hills become gradually cooler in colour and paler in tone, creating the feeling of recession. The dark, shadowed hill on the right pushes back the distant hill behind it even further. Don't be afraid to use strong, dark colour when necessary. Being timid is the short-cut to mediocrity in a painting!

YOU WILL NEED
Rough paper, 490 x 350mm (19¼ x 13¾in)
Masking fluid
Sponge
Raw sienna
Cobalt blue
Neutral tint
Sepia
Burnt umber
Aureolin
White gouache
Old paintbrush
1cm (½in) flat brush
Large filbert wash brush
Round brushes: no. 16, no. 12, no. 8, no. 4, rigger
Craft knife blade

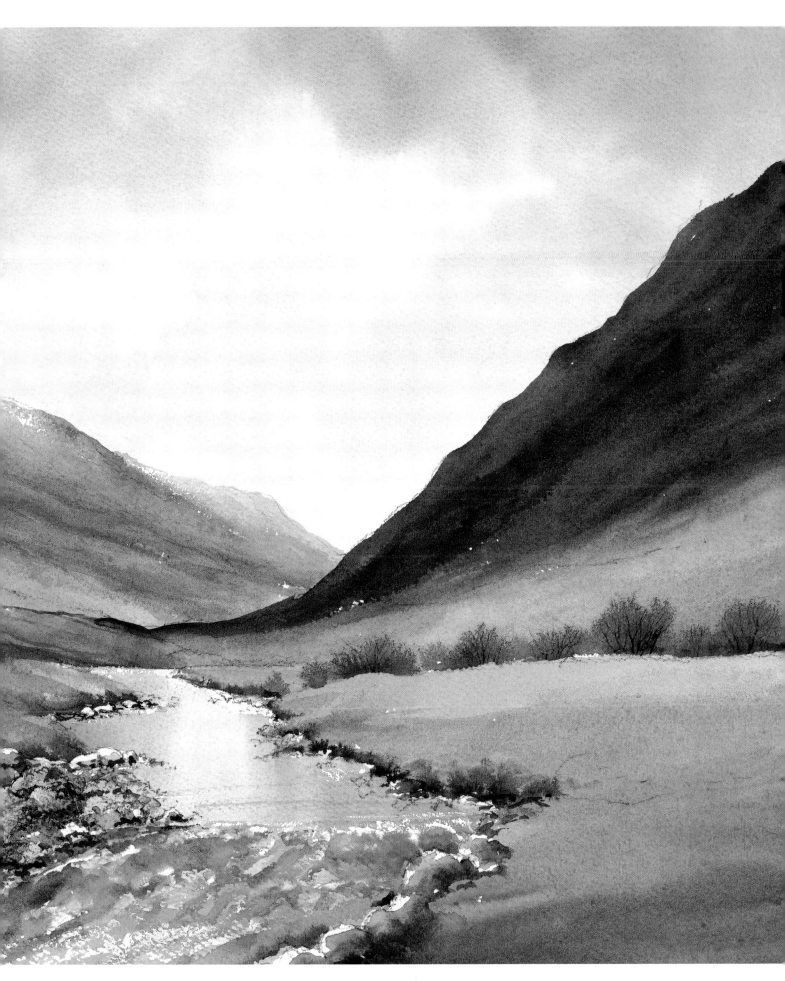

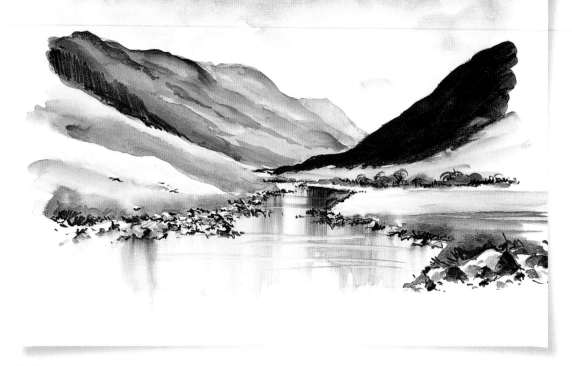

Preliminary sketch

Unlike the other step-by-step exercises in this book, which are worked from photographs I have taken, I felt that I captured this wild scene perfectly in a sketch made on location using water-soluble pencils. With all the information I needed contained in this sketch (or, in the case of a few colour notes, made in the margin), I decided to work directly from the sketch for this exercise.

Water-soluble pencils

To add a bit of variety when sketching, I like to use water-soluble pencils (see page 16) which are an ideal tool for quick thumbnail sketches. You can get water-soluble coloured pencils, but for spontaneous, small sketches, I find graphite ideal.

Combining the immediacy of a pencil sketch with the fluidity of watercolour, water-soluble graphite pencils are available in a variety of grades similar to traditional sketching pencils. I have in my set a 2B, 4B, 6B and 8B, though I tend to use just two: once I have used the 2B for a few outlines, I tend to sketch in the tones using the 8B. This soft dark pencil will give me the rich tones that I need for the darker areas, and with the addition of a little water, will also produce a softer, lighter grey for midtones.

A good tip when working with these pencils is to scribble, quite heavily, on a corner of your paper, then use a wet brush to pick up and apply it to the paper – using the scribble as a 'reservoir of tone'. Obviously the more water you use the lighter the tone. Using this method you can really explore a full range of tonal values, which are vital to create a good painting when you paint the scene from your sketch, this time using colour.

1 Use an old paintbrush to paint masking fluid on the line where the river bends out of view, and on the tops of the rocks and stones.

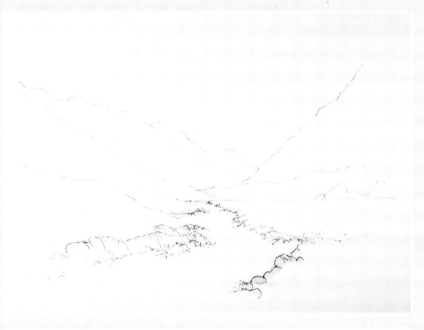

2 Mix four sky washes in advance so that they are ready for painting quickly: raw sienna, cobalt blue, neutral tint and finally sepia. Wash the sky area with clean water applied with a sponge, coming down below the tops of the hills.

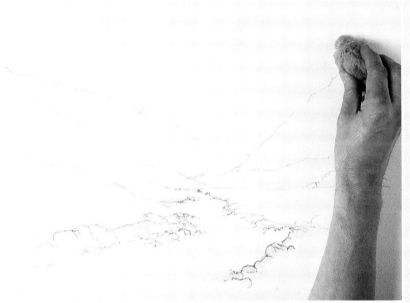

3 Wash raw sienna on to the lower part of the sky, then carefully float in some cobalt blue. Don't swirl it around too much or you will create a green. Then add neutral tint towards the top, and finally sepia at the very top. This will make the sky considerably darker at the top and lighter towards the horizon, creating aerial perspective. Allow the sky to dry.

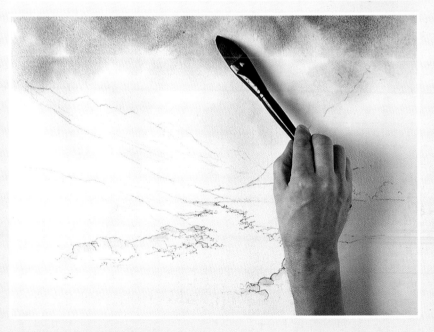

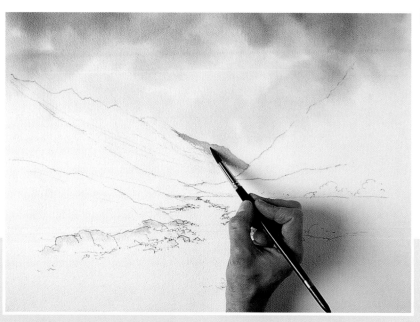

4 Using a fairly dry no. 12 brush, paint the distant hills in pale cobalt blue, greyed slightly with neutral tint.

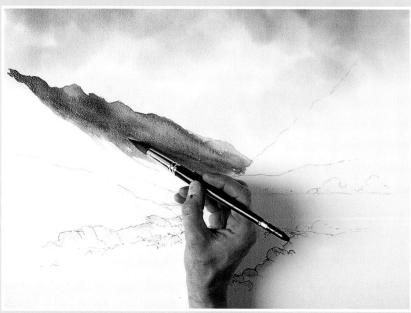

5 Add burnt umber to the cobalt blue/neutral tint mix to warm it, and paint the middle distance using a no. 16 brush. Paint more cobalt blue and neutral tint at the top and a little raw sienna for more warmth at the bottom.

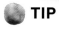 **TIP**

In a mountainous scene like this, it is important that your brush strokes follow the contours of the land.

6 Add a green mixed from aureolin and cobalt blue. Wash cobalt blue mixed with neutral tint over this, working wet in wet to avoid making stripes. This will darken the area, to contrast with the lighter hill. Wash sepia on top to darken it further. Add more cobalt blue and neutral tint to suggest dark cloud shadows. Allow to dry.

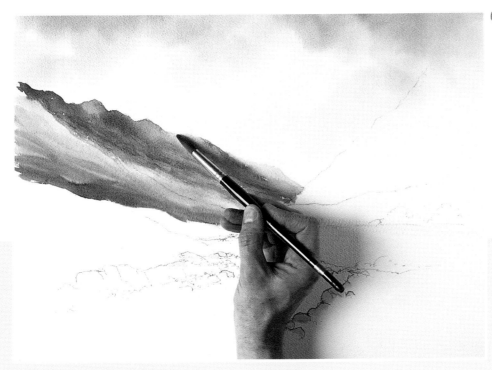

7 Brush the most distant hill with clear water fading it to push it further back into the scene. Make sure it is fully dry beforehand, or you will remove the pigment rather than just fade it. Using a no. 12 brush and cobalt blue mixed with neutral tint, add streaks. Use sepia to paint in the dark ravine, and fade the top using clear water again.

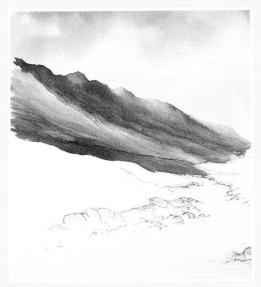

8 Use sepia to create crags and gullies on the left of the green area, and neutral tint with cobalt blue to reinforce the darks, for greater contrast with the lighter hill. Streak in the darker paint with a dry brush to give the land a rough look.

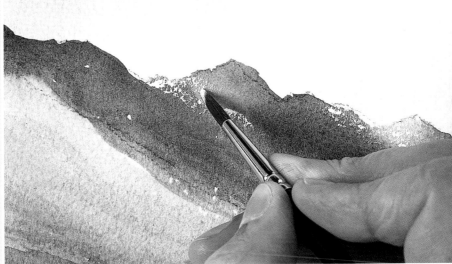

9 Using neat white gouache straight from the tube, catch the surface of the Rough paper very lightly on the tops of the hills to suggest snow. You can use a damp brush in one or two places to lighten the gouache.

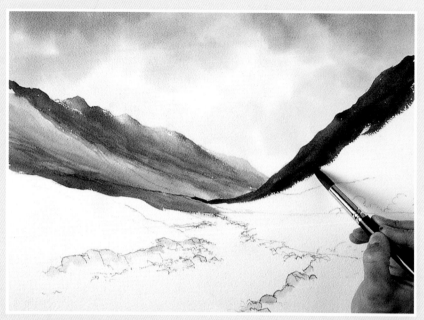

10 Paint the dark hill on the right using a no. 16 brush and a mix of burnt umber with neutral tint. This must be strong enough to make the distant hill behind it appear to recede, so cover all the white paper.

11 Carry on down the hill painting wet in wet and bringing in raw sienna for brightness and a touch of green mixed from aureolin and cobalt blue. To paint the stand of trees on the right of the painting, mix burnt umber and neutral tint and drop soft shapes into the wet paint. Use the same dark paint to darken the upper part of the hill on the left, to create contrast with the lighter part to come. Allow to dry.

12 Make a thin wash of raw sienna for the brightness on the left-hand middle ground. Paint a stronger mix of raw sienna and burnt umber on top, softening it into the contrasting dark above it. Add cobalt blue and neutral tint to darken the area in streaks. Bring in some green mixed from aureolin and cobalt blue.

13 Use a dry brush with burnt umber to paint streaks of dark into this triangle of land, to give it a patchy look. Take a no. 8 brush and use a dark mix of burnt umber and neutral tint for the dark areas of soil where the land meets the water, allowing this to drift into the lighter colour above it.

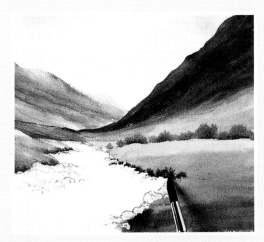

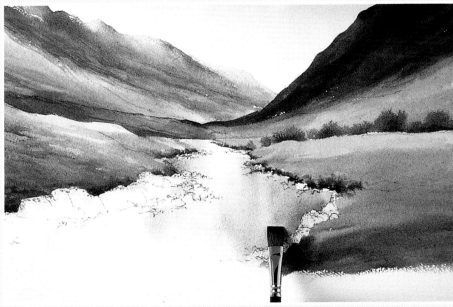

14 On the right-hand side of the river, wash on raw sienna to contrast with the dark hills. Add raw sienna and burnt umber to give a warm brown tint. Mix green from aureolin and cobalt blue. Paint raw sienna, burnt umber and green towards the foreground, leaving spaces for stones. Use burnt umber and neutral tint for the dark patch at bottom right. Paint dark brown for the soil at the river's edge.

15 Rub off the masking fluid from where the river bends out of view. The river is painted in two parts; firstly the slow flowing part that reflects the sky. Take three separate washes: cobalt blue, neutral tint and raw sienna. Wet the reflective river area with clean water down to where the river rushes, then float the three colours into this wet background. Immediately, using a 1cm (½in) flat brush, drag the colours down vertically to the stones. Allow to dry.

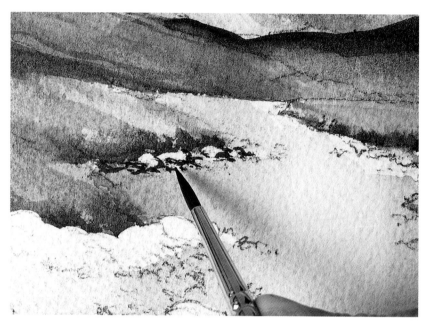

16 Rub off the masking fluid from the stones. Take a no. 4 brush for the smaller stones and a mix of burnt umber and neutral tint and work the shapes of the stones. Make tiny marks to create form – do not attempt to draw round the stones, or they will look flat.

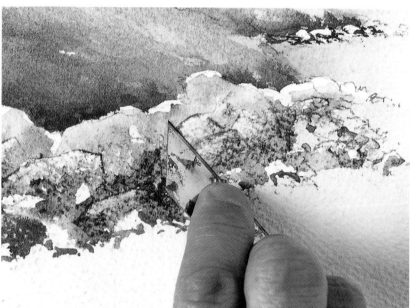

17 Wet the area of the stones in the middle ground. Make a thin wash of raw sienna and float it in, then drop in cobalt blue on top, and neutral tint on top of that. Make a very dark mix of burnt umber and neutral tint and drop that in wet in wet. Take a craft knife blade and move the colours around by scraping it over the paper, using the flat of the blade to create form and texture.

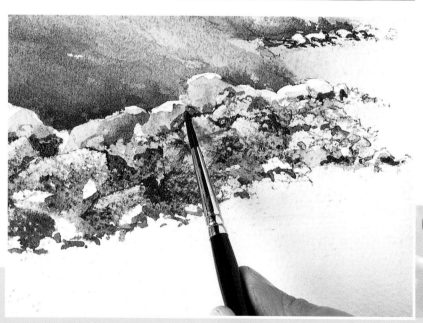

18 Take a no. 4 brush and mix a dark shade of burnt umber and neutral tint. Work this dark into the rocks to emphasise their shape. Allow the painting to dry.

TIP

It is important to use colours for the stones that have already been used elsewhere, or the stones will look as if they belong in another painting.

19 Paint some of this dark brown into the rocks in the foreground and allow to dry once more.

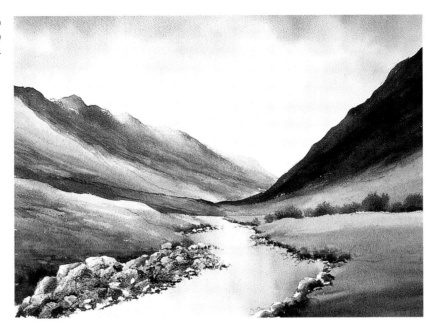

20 Find the horizontal line in the painting where the water begins to run downhill. Drop in a little neutral tint and sepia, then take a no. 8 brush and use white gouache straight from the tube, adding this while the watercolour is dry in some parts, wet in others, to suggest foam. The white gouache can also be used to suggest splashes and add horizontal lines in the water.

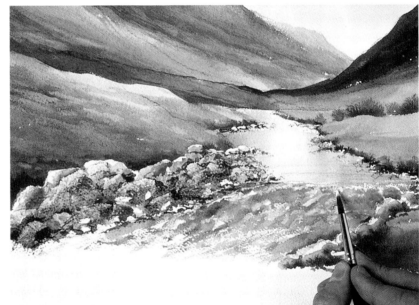

21 Develop the shapes of trees using a rigger brush and burnt umber mixed with neutral tint to indicate the branches. Paint the trees, as always, from the bottom up.

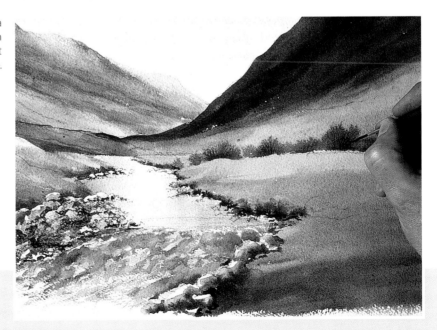

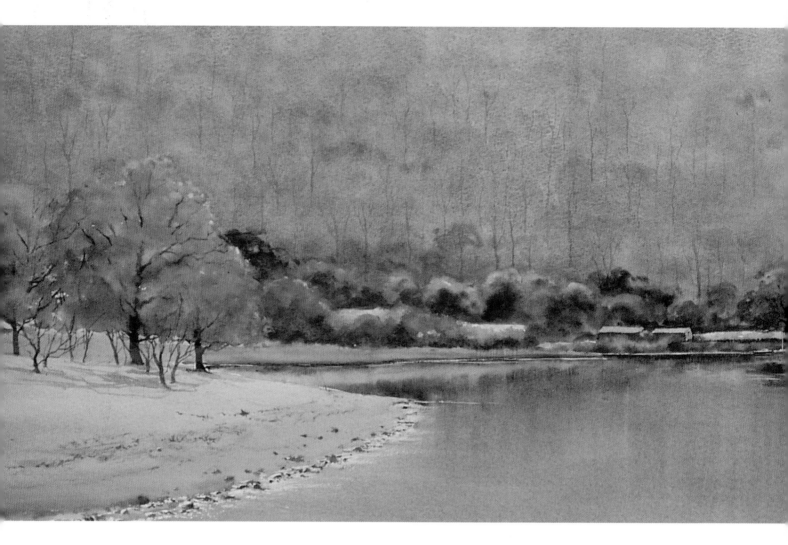

Derwentwater in Cumbria

685 x 305mm (27 x 12in)

Sometimes, as in this instance, there is no (or very little) sky visible in the background, nor is there a valley or dip between the hills that provides us with a convenient path through the scene (as in the *Glencoe* project). In this painting, the method I have used to make this almost solid wall of wooded hillside appear distant is to paint it wet into wet using light bluish-grey washes. This gives it a misty look which helps to place it in the background. Note how the middle distance trees at the base of the hills, and the ones on the banks either side, are painted in stronger, more contrasting colours. It is also worth noting that I have subtly introduced a few touches of the autumn colours amongst the misty, bluish-grey background washes. These help to unify the scene and avoid the background hill appearing like a separate entity. To create the reflections in the lake, I have used the method described in step 15 of *Glencoe* on page 69.

Watendlath Beck, Cumbria

420 x 292mm (16½ x 11½in)

A beautiful location with a paintable view in every direction. It has all the right ingredients: a packhorse bridge, rustic old farm buildings and a shallow beck or stream leading to a still mountain lake, all set to a backdrop of the Cumbrian hills. All elements in the scene lead the viewer to the focal point of the bridge. Note the person on the bridge wearing red which catches the eye, and how the tonal value of the hills is reduced as they recede into the distance. You don't have to work too hard on rocks and stones: observe how simply they have been treated here – just as areas of light and shadow.

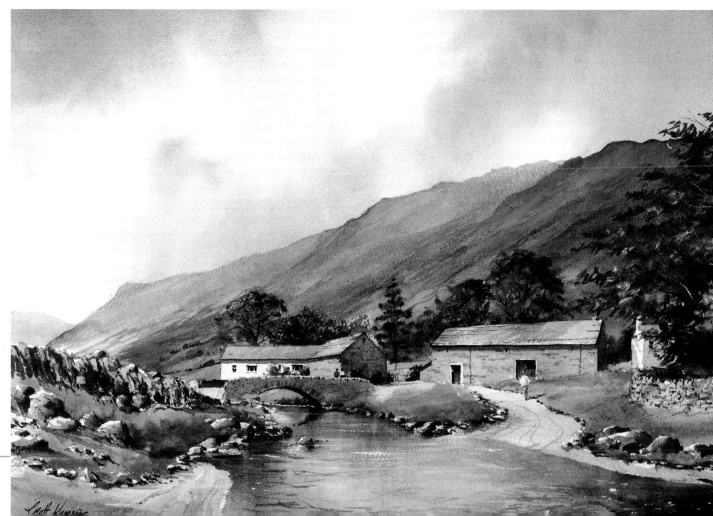

Boats at Bosham Quay

In this painting the distinctive shape of the Saxon church across the water makes an excellent focal point. Note how this is a third of the way into the picture, always a good position compositionally. The cluster of boats makes excellent foreground detail, but note how I have reduced the number of these and altered their positions slightly. You don't have to copy slavishly what is on your photograph; you should take some time at the outset to consider any changes or simplifications you wish to make. I have found that most picture buyers, even if they are familiar with the location, expect you to use some artistic licence.

YOU WILL NEED

Rough paper, 550 x 370mm (21¾ x 14½in)
Masking fluid
Cobalt blue
Cobalt violet
Cerulean blue
Aureolin
Viridian
Burnt sienna
Raw sienna
French ultramarine
Cadmium red
Naples yellow
Burnt umber
Lemon yellow
White gouache
Old paintbrush
Large filbert wash brush
Round brushes: no. 8, no. 4, no. 16
Kitchen towel

The finished painting

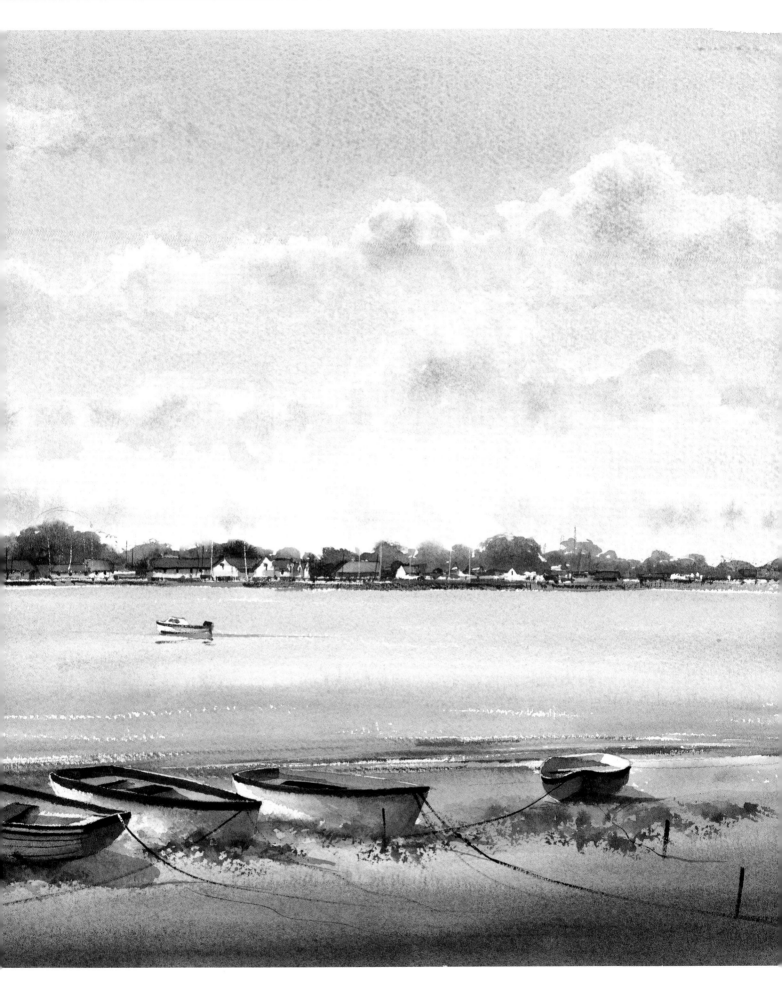

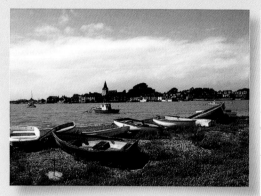

Source photograph

I took many shots of this scene, as I often do, to give me plenty of choice back at the studio. I chose this one for the jumble of boats that added a lot of interest to the foreground.

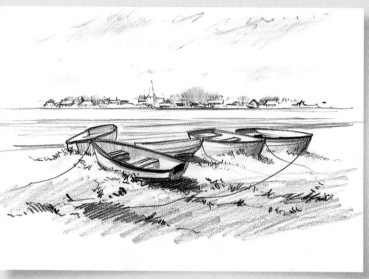

Preliminary sketch

Before setting about the finished painting, I used a quick pencil sketch to simplify the foreground, deliberately not including all the boats. What to leave out and what to put in is a personal decision and one you have to get into the habit of making yourself.

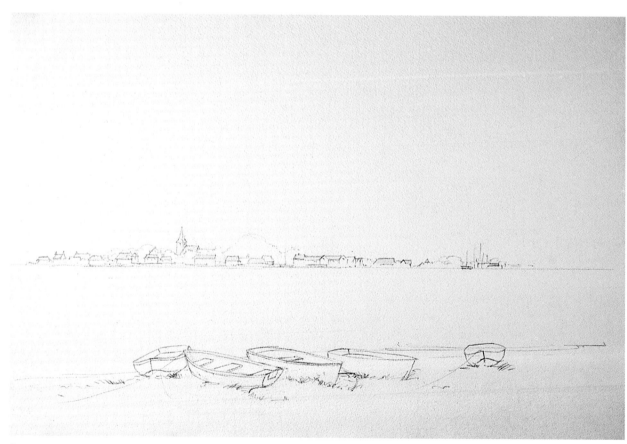

1 Sketch the scene and use an old paintbrush to apply masking fluid to the rooftops of the buildings across the estuary. Do not mask the boats yet, or your hand will disturb the masking fluid as you work on the top of the painting.

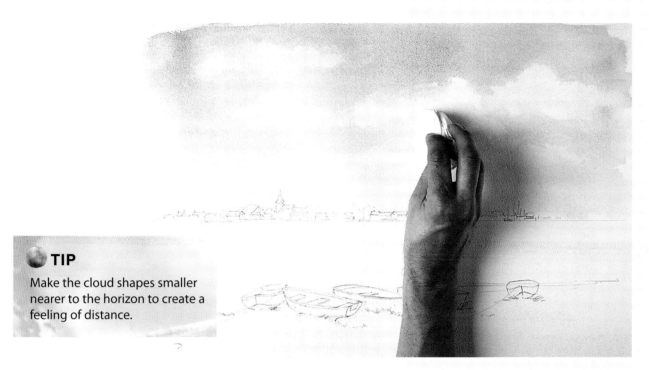

● **TIP**

Make the cloud shapes smaller nearer to the horizon to create a feeling of distance.

2 Mix two washes for the sky: cobalt blue with cobalt violet for the top of the sky and cerulean blue for the lower part of the sky. Using this colder blue near the horizon will make it look further away, helping the aerial perspective. Wet the sky area and paint on the washes wet in wet using a large filbert wash brush. Immediately dab areas with a kitchen towel to suggest clouds. Allow the painting to dry.

3 Now work on one cloud at a time, re-wetting each one with clear water, then dropping in a cloud shadow colour mixed from cerulean blue and cobalt violet. Move on to other clouds and work them in the same way. Continue softening the clouds with clear water to prevent hard lines from forming; you are trying to achieve a soft, vaporous look. Allow to dry.

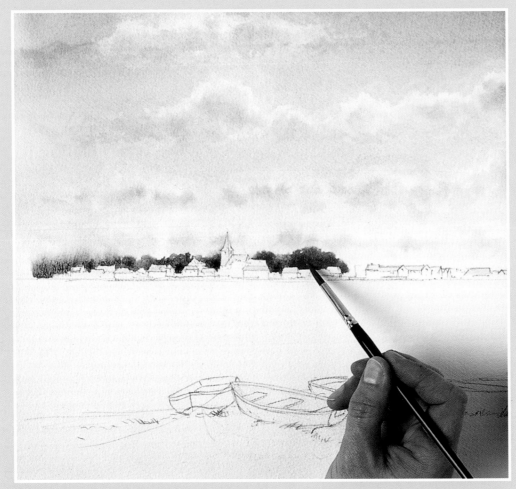

4 Mix cobalt blue and cobalt violet with aureolin. Take a no. 8 brush and paint vague tree shapes in the distance. Before they are dry, soften the edges with a clean, damp brush to make them recede into the distance. Make some trees softer and leave others with harder lines for variety. Drop viridian and burnt sienna into one or two of the tree shapes to make them bolder.

5 Remove the masking fluid from the rooftops. You may need to tidy up some of the edges using background colour and a no. 4 brush.

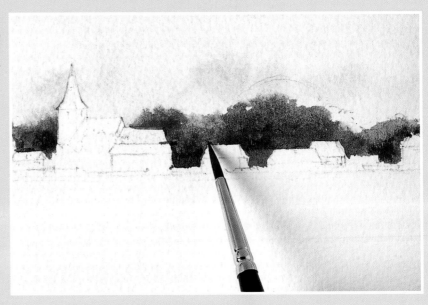

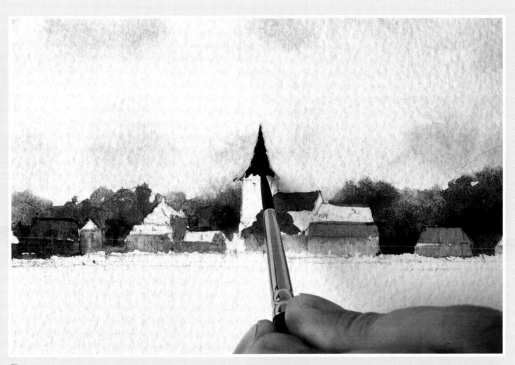

6 Mix four washes for the buildings: aureolin and burnt sienna for the roofs; raw sienna; burnt sienna and cobalt blue and burnt sienna with French ultramarine for darker details. Paint shapes for the roofs and buildings: you are not looking for accuracy but for general rectangular shapes which will suggest walls and rooftops. Use the dark brown for shadows and to paint the suggestion of windows with a dash of the no. 4 brush. Mix two greens: viridian with burnt sienna and aureolin with cobalt blue, and drop in trees in front of the buildings. Paint the church steeple in a mid-brown made from cobalt blue and burnt sienna.

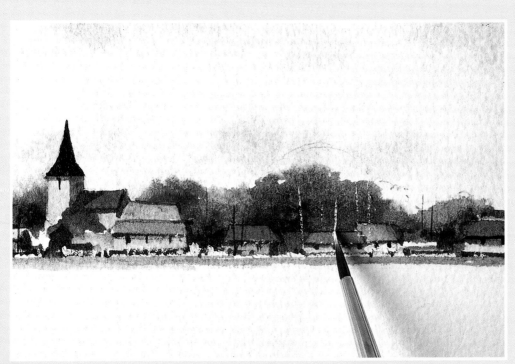

7 Continue to paint finer details with the dark brown mix and the shadow on the right-hand side of the church. Paint masts using white gouache straight from the tube. Add a few small shapes to represent vehicles on the road and boats on the quayside using bright colours such as cadmium red and cerulean blue; don't try to render these in any great detail – a suggestion is far more interesting.

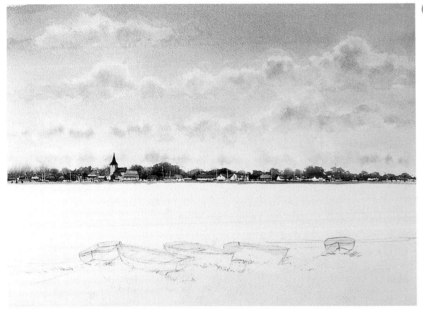

8 Paint masking fluid on to the top parts of the boats so that you can paint the sea and sand washes behind them without losing the shapes. It is important to stand back and have a good look at a painting at stages along the way. At this point I decided that the distance looked too sharp, which reduced the effect of aerial perspective. If this seems a problem, take a mix of cerulean blue and cobalt violet, like the one used for cloud shadows, and paint a haze over some of the background. Leave the church sharp and clear so that it remains the focal point of the painting.

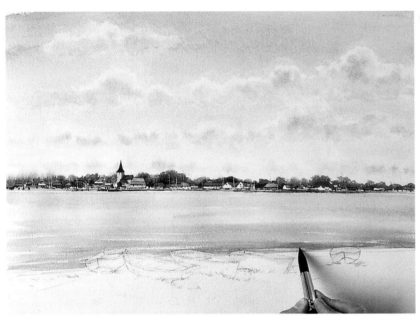

9 Mix washes for the water. The water will show some reflection of the sky colours, so you will need cerulean blue with cobalt violet. However, the water will be greyer than the sky, so make another wash of cobalt blue and cobalt violet, but grey it using burnt sienna. Take a no. 16 brush and paint the cerulean blue and cobalt violet wash at the top of the water area in quick horizontal strokes, catching the surface of the paper so that some white shows through. Leave a tiny white line at the quayside. While the paint is wet, drop the greyer colour in wet in wet. Add raw sienna to warm the foreground and to suggest a glimpse of sand showing through the water.

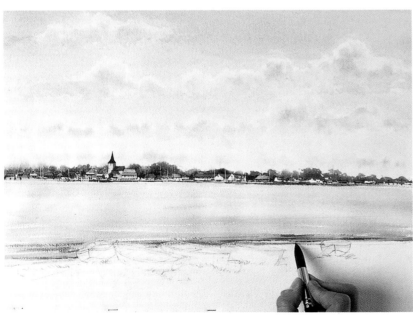

10 Leave a little white paper at the water's edge to suggest foam, and add a little dark shadow underneath using cobalt blue and burnt sienna.

11 Paint the sand between the boats using Naples yellow mixed with burnt umber and a little cobalt violet. Fade the edge with clear water to avoid a hard line forming later. Allow to dry, then rub the masking fluid off the boats.

12 Start to build up the boats using a no. 8 brush and some fairly bright colours: burnt sienna and burnt umber; cerulean blue; raw sienna; burnt sienna and French ultramarine for darker details and cobalt blue and cobalt violet with a little burnt sienna for shadows.

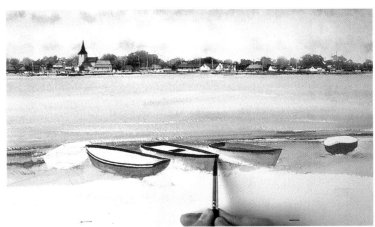

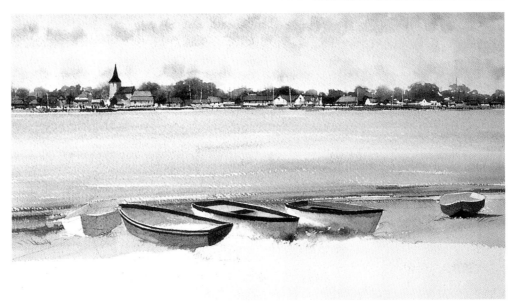

13 Continue building up the boats. Bear in mind that the light is coming from the left, so some white paper can be left on this side for highlights. The shadows should be painted using the sky colour cobalt blue and cobalt violet; they should be transparent so that the boat's colour shows through, and they should be more intense further away from the light. Paint the insides of some of the boats with a thin grey wash and add shadows. Add a dark brown mixed from burnt sienna and French ultramarine for the tar on the base of the boats.

14 Continue building up the insides of the boats, using your reference photograph for details. Use French ultramarine for the rim of the left-hand boat. Work wet on dry, waiting for one colour to dry before carrying on with that area. Paint round the seats in the foreground boat and place dark brown shadow underneath them.

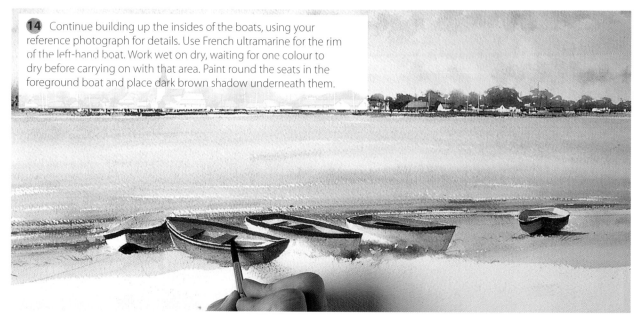

15 Some of the boats in the photograph were made from fibreglass, but it adds interest if you paint them as clinker-built boats, made from overlapping planks. Suggest this using swift strokes in the same dark brown. Paint the boats in the harbour in less detail, using white gouache with cerulean blue for the left-hand boat and with burnt umber for the right-hand one. Touch the bottoms of the boats in white gouache to place them in the water. Use the same gouache for the highlights on the foreground boats, the waves at the water's edge and for the ropes where they cross a dark background.

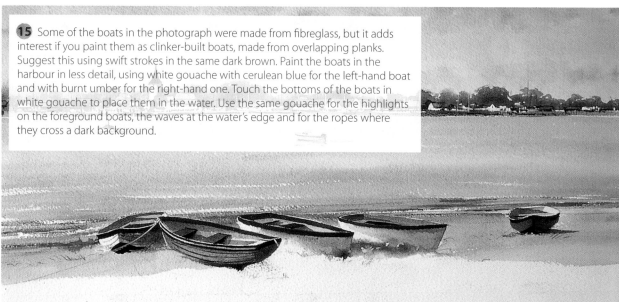

16 Mix Naples yellow and burnt umber with a hint of cobalt violet for the foreground sand. Use a no. 16 brush to sweep the sandy wash across. At the bottom edge add burnt umber and cobalt blue so that the foreground is darker, thus bringing it forward.

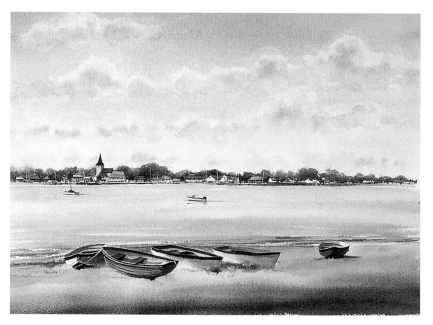

17 Dampen the sides of the boats and use a no. 8 brush and lemon yellow to suggest greenery growing round the boats. Drop a dark green mixed from viridian, French ultramarine and burnt sienna on top. I have painted less greenery than actually appears in the reference photograph, because I like the colour of the sand.

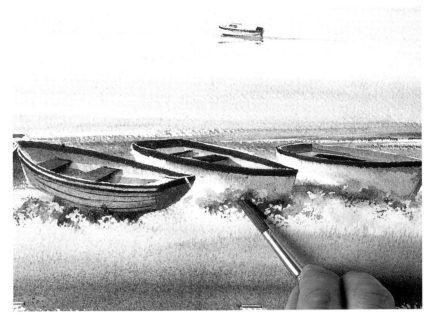

18 Paint the shadows cast by the boats in cobalt blue and cobalt violet. Soften the shadows into the hulls of the boats. Darken the weed around the extreme left-hand boat to contrast with the light tone of the hull.

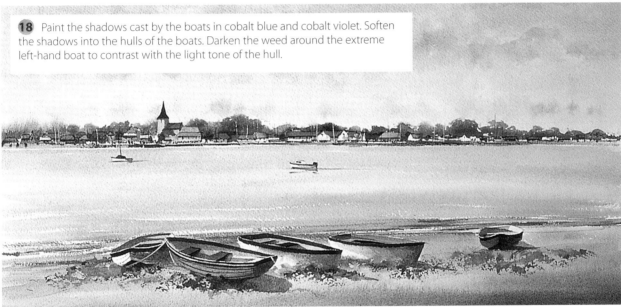

19 Paint the parts of the ropes that appear darker using burnt sienna and French ultramarine and a no. 4 round brush. Streak them in quickly, dark against light. After this I added posts for the ropes and the posts' shadows (see the finished painting on pages 74–75).

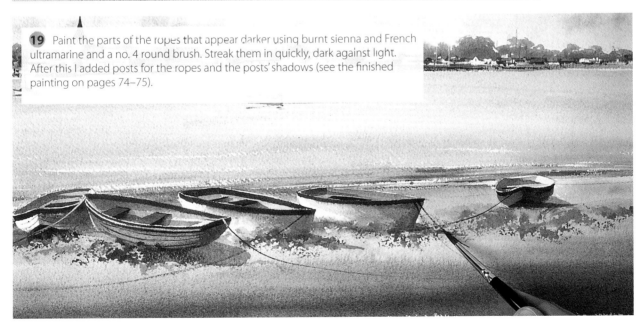

83

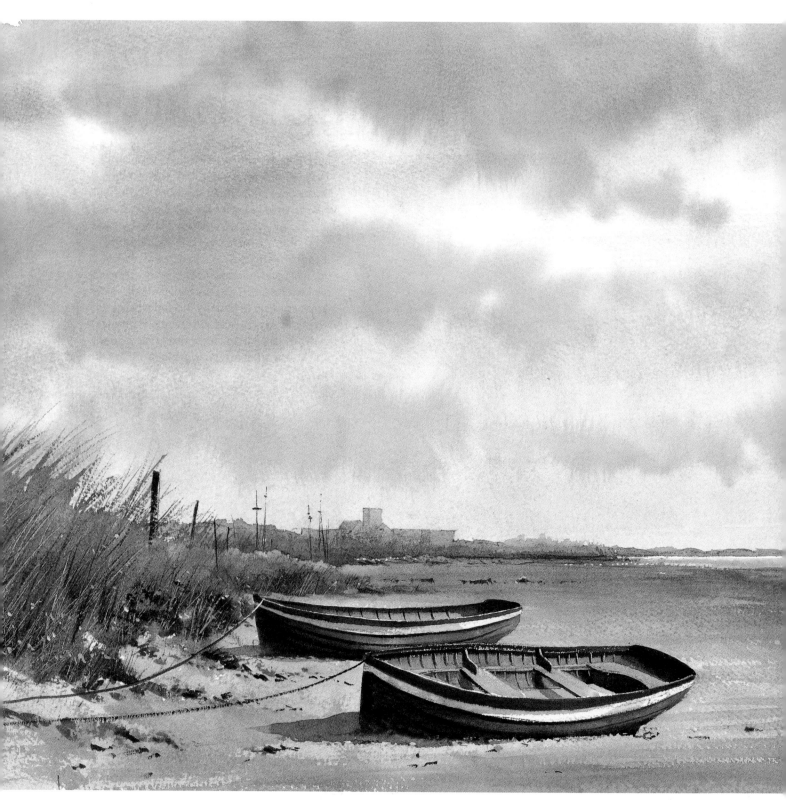

Gibraltar Point, Lincolnshire

508 x 330mm (20 x 13in)

Just a three-mile walk along the beach from the hurly-burly of Skegness on the Lincolnshire coast lies this quiet stretch of beach where all you can hear is distant birdsong. A scene like this is three-quarters sky, and it presents the watercolourist with a marvellous opportunity to create atmosphere. The sky is painted with three separate washes: Naples yellow with rose madder, a mix of cerulean and cobalt blue and a wash of neutral tint with just a touch of rose madder. I sloped the paper slightly and floated the washes into a wet background, determined to work on it very quickly, then leave it alone to perform its magic. There were no boats on the sand – I cheated by adding these from a separate sketch.

Staithes, Yorkshire Coast

460 x 305cm (18 x 12in)

A haven for artists, this little coastal village with its weathered cottages and jumble of outbuildings is a world away from Bosham, the scene of the main painting in this chapter. This has been painted with a limited palette of six colours. Note the light against dark in the left-hand third of the scene, where the road disappears out of view. This is a really bright area that gives the painting a glow and draws the viewer's attention.

Cromford Canal

This little stretch of canal near Matlock Bath in Derbyshire, now a favourite spot for weekend walkers, was once the main transport route to and from a cotton mill, representing a significant part of the North of England's industrial heritage.

I love painting scenes like this where the initial stage consists of laying in a series of wet in wet washes, loosely forming the shapes of the foliage. The key to this scene is simplification. If you try to copy every bit of foliage too literally, the result will look crowded and overworked. Your aim should be to capture the essence of the subject.

YOU WILL NEED

Rough paper, 360 x 270mm (14¼ x 10¾in)
Masking fluid
Cobalt blue
Rose madder
Naples yellow
Lemon yellow
Aureolin
Viridian
French ultramarine
Burnt sienna
Cobalt violet
Raw sienna
Indian yellow
White gouache
Old paintbrush
2.5cm (1in) flat brush
1cm (½in) flat brush
Round brushes: no. 12, no. 10, no. 8, no. 4, rigger
Kitchen towel

The finished painting

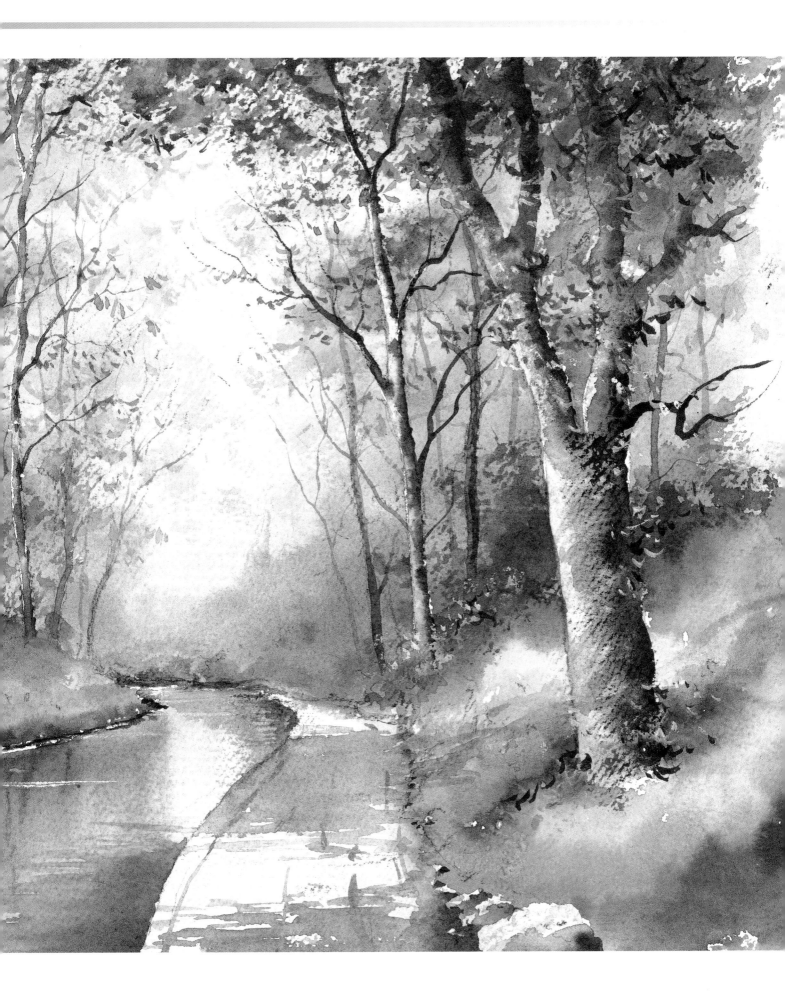

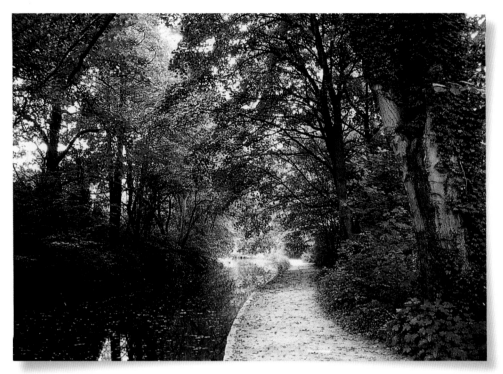

Source photograph

When you are presented with the mass of foliage and jumble of branches, a scene like this seems a daunting prospect, but doing the pencil sketch really starts you thinking about how you can simplify it. What to leave in and what to leave out?

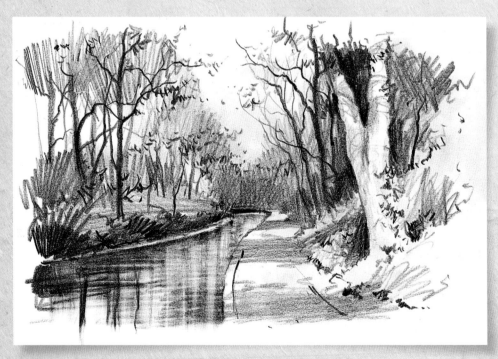

Preliminary sketch

I created the feeling of reflections in the water simply by running a putty eraser over the sketch in vertical strokes.

1 Draw the scene. Using an old paintbrush, apply masking fluid to the edge of the path to protect it later when you paint the water. Mask the large tree and one or two tree trunks where the trunk will be lighter than the background.

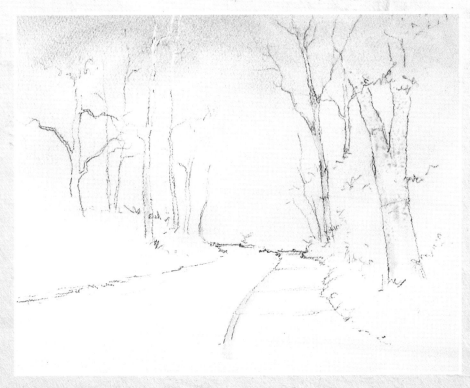

2 Much of the background will be painted in one go, floating colours on to wet paper. Mix seven washes before you start: 1) cobalt blue and rose madder; 2) Naples yellow and rose madder; 3) lemon yellow; 4) green mixed from aureolin and cobalt blue; 5) Naples yellow and lemon yellow; 6) viridian, French ultramarine and burnt sienna; 7) viridian and cobalt blue. Wet the paper down to the ground with a 2.5cm (1in) flat brush. Wash on cobalt blue and rose madder at the top, then Naples yellow and rose madder to create a pale pink glow in the lower part of the sky.

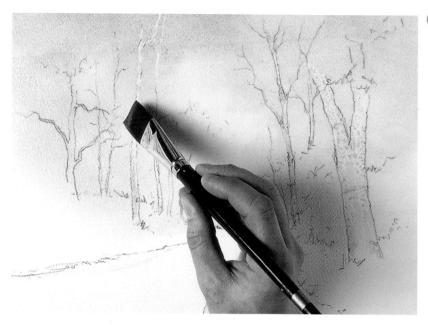

3 Float in a wash of lemon yellow followed by a mixture of lemon yellow and Naples yellow. If these look a bit too acid at first, don't worry; the colour will change as the later washes fuse in with them.

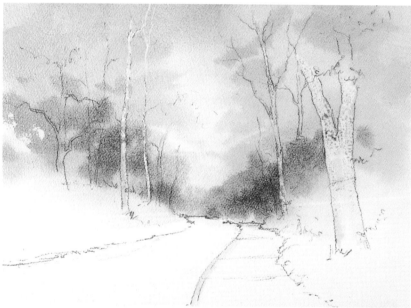

4 Still using the 2.5cm (1in) flat, continue adding colours, working light to dark. Add the green made from aureolin and cobalt blue. Change to a no. 12 round brush and add rose madder and cobalt blue for the browner colour near the ground. Add more green wet in wet.

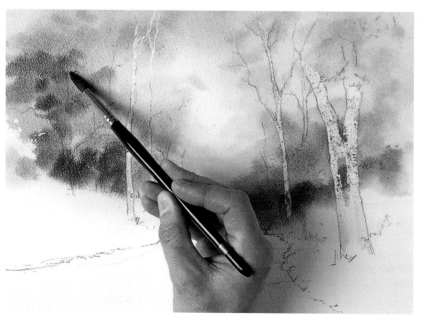

5 Add the deep green made from viridian and cobalt blue. It will mix with the other colours on the page. Where a rich, dark green is required, add viridian, French ultramarine and burnt sienna. Use the side of your no. 12 round brush to make shapes to suggest foliage.

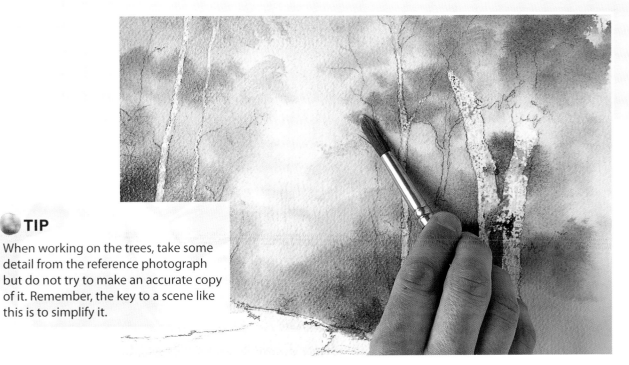

TIP

When working on the trees, take some detail from the reference photograph but do not try to make an accurate copy of it. Remember, the key to a scene like this is to simplify it.

6 Still working on the damp background, take a no. 10 brush and more bright green. Use dry brush work so that some of the marks look dry and others blend in for variety.

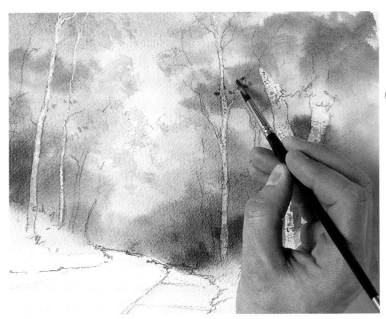

7 Continue with the same technique using viridian and cobalt blue. Take a no. 8 brush and work the shapes at the edges of the branches using aureolin and cobalt blue. At this stage the shapes begin to look like leaves and the washes should suggest tree shapes.

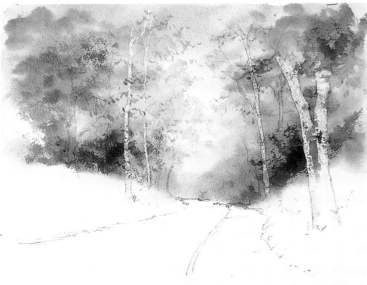

8 Apply the dark green in the same way. The darkest greens should appear at the base of a tree. Use cobalt blue and rose madder for the purplish foliage at the top right and far left.

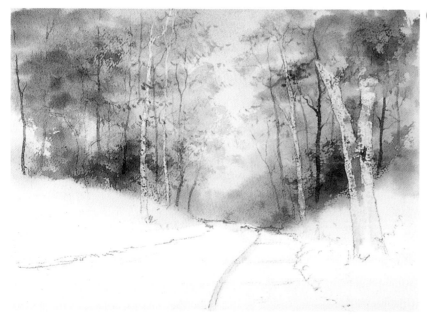

9 Paint the distant tree trunks with a mix of cobalt blue, rose madder and burnt sienna, working upwards with a no. 8 brush. Use a lighter version of the mix for faraway trees, and paint some of them with the side of the brush and the dry brush technique to add to the distant feel. Use the same colour at the centre of the painting over the bend in the canal.

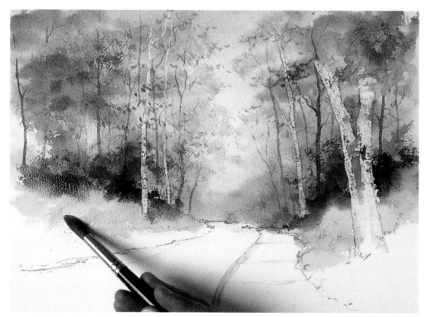

10 Paint darks on the far right of the painting to contrast with the tree. The colours should merge with the wet background. Push the paint around quite vigorously using a worn brush. Add lemon yellow. Use viridian and cobalt blue for the cool green at the base of the left-hand trees. Paint the bank on the left with lemon yellow and Naples yellow. Add warmth using raw sienna and burnt sienna.

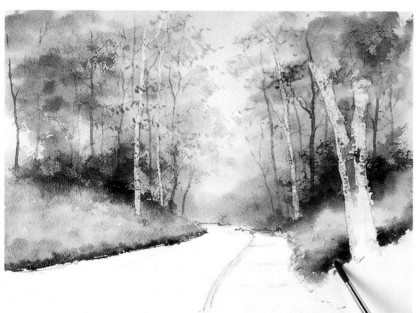

11 On the left of the painting, paint the green mixed from cobalt blue and aureolin down to the canal's edge. Add lemon yellow for brightness and Naples yellow for creamy highlights. While the painting is still wet, paint the darks by the water's edge using the mixture of viridian, French ultramarine and burnt sienna. Brown this area using burnt sienna to suggest the exposed soil on the bank under the trees. On the right-hand bank, paint raw and burnt sienna for warmth and add lemon yellow and then dark green down to the right-hand bank. Add darks round the tree trunk, and cobalt blue mixed with aureolin around the base of the trunk.

12 Add a hint of cobalt blue and rose madder at the edge of the path, and burnt sienna for a touch of warmth. Allow the painting to dry.

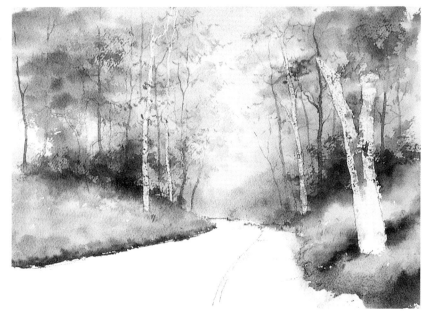

13 Rub the masking fluid off the trees. Mix burnt sienna and cobalt blue to make brown, warm it with a touch of rose madder and paint the dark tree on the left. This should be a stronger mix than used for the trees behind it to make it appear further forward. Leave some gaps in the top of the trunk so it appears as though you are glimpsing it through the foliage.

🔵 TIP

When painting from a complex photograph like this, it is fine to use it as inspiration, but do not copy it slavishly.

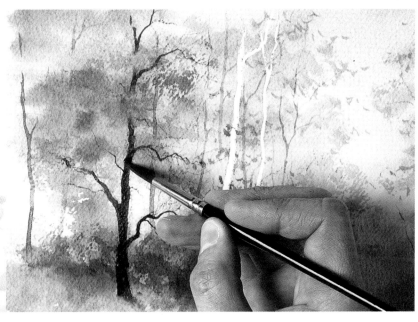

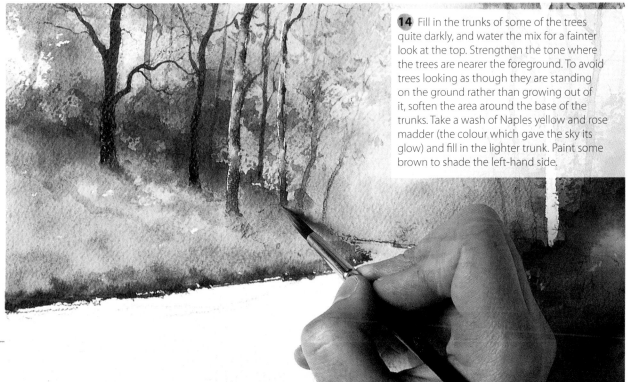

14 Fill in the trunks of some of the trees quite darkly, and water the mix for a fainter look at the top. Strengthen the tone where the trees are nearer the foreground. To avoid trees looking as though they are standing on the ground rather than growing out of it, soften the area around the base of the trunks. Take a wash of Naples yellow and rose madder (the colour which gave the sky its glow) and fill in the lighter trunk. Paint some brown to shade the left-hand side.

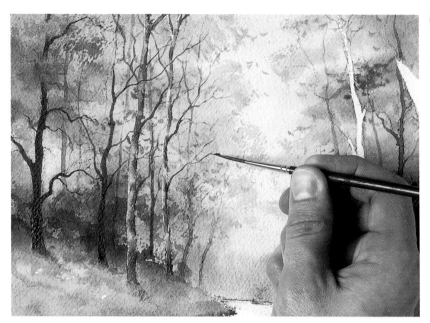

15 Use more dark brown and a rigger brush to put in the very fine branchwork at the top of the tree. This makes sense of the foliage you have already painted by connecting it to the tree.

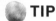

● TIP

With a subject like this it is important to keep reminding yourself which direction the light is coming from.

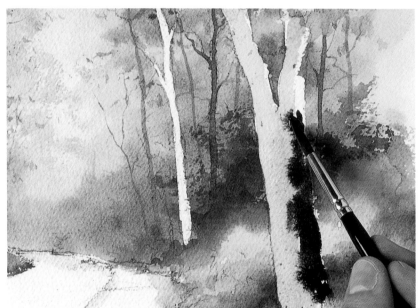

16 Paint the right-hand trees in the same way, wet in wet. Paint pink on to the lighter trees, using Naples yellow and rose madder. Add cobalt blue and rose madder. Drop in burnt sienna for the base of the tree, and burnt sienna and French ultramarine with a little rose madder to shade the right-hand side.

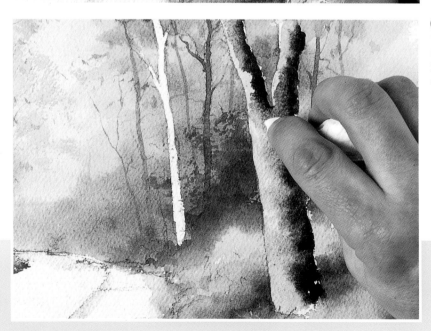

17 Continue with the right-hand tree. Use the Rough paper and a bit of dry brush work to create the effect of bark. Soften the trunk with clear water and create texture by dabbing with a piece of kitchen towel.

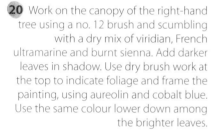

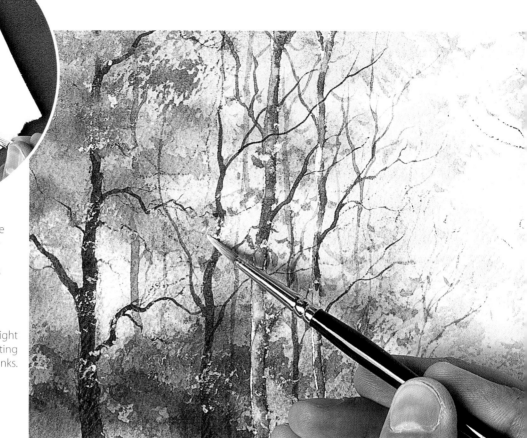

18 On scrap paper mix white gouache with lemon yellow and white gouache with viridian. Do not mix these in the palette, or for several weeks afterwards you may find that the colours you mix take on a chalky appearance.

19 Use the gouache mixes to highlight the foliage with small marks interrupting the view of the trunks.

20 Work on the canopy of the right-hand tree using a no. 12 brush and scumbling with a dry mix of viridian, French ultramarine and burnt sienna. Add darker leaves in shadow. Use dry brush work at the top to indicate foliage and frame the painting, using aureolin and cobalt blue. Use the same colour lower down among the brighter leaves.

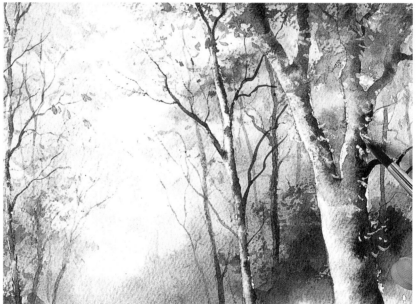

21 Create more texture on the bark if necessary, using burnt sienna and cobalt blue with a little rose madder and dry brush work. Add a hint of warmth by painting on burnt sienna in the same way.

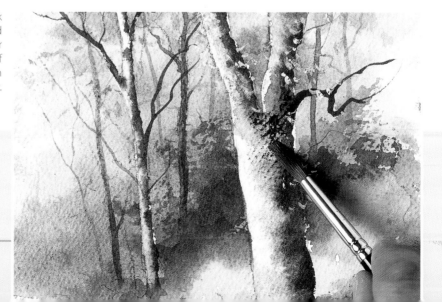

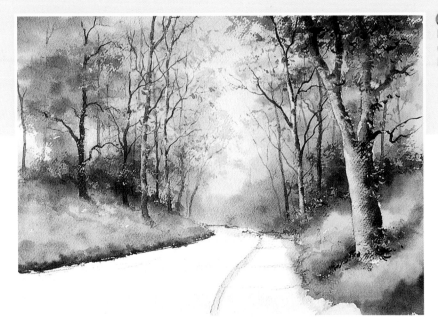

22 Make very dark marks on the bark using burnt sienna and French ultramarine. Touch in foliage around the base of the trunk.

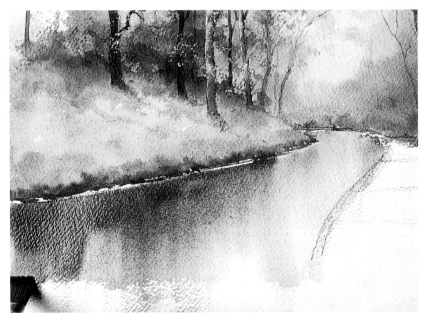

23 Most of the colours you have already used are needed for the reflections. Rub off the masking fluid at the top of the canal bend and neaten the edges. Wet the whole water area, leaving a fine gap along the left-hand edge dry to separate the canal from the bank. Drop in reflection colours: yellow, purple, pink at the bottom from the sky, green in the middle. Reflect the brown darks from the bank, working quickly while the painting is wet. Add viridian and browns at the top right-hand edge of the canal. Add lemon yellow for brightness. Take a damp 1cm (½in) flat brush and drag down the reflection colours in vertical strokes. You have to work rapidly on this stage as the dragging down effect will not work on dry paper.

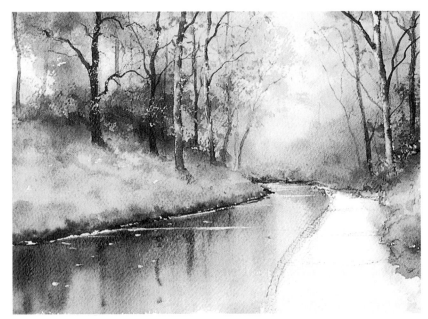

24 Work on the details of the water. Using a no. 4 brush, darken the water's edge with a very dark brown and dampen it in with green. Tint the white line at the water's edge using a little raw sienna. Use white gouache straight from the tube to paint horizontal streaks on the water's surface. Mix Indian yellow with white gouache to paint the leaves floating on the surface. Touch in dark reflections of tree branches.

25 Mix a pink colour again using Naples yellow and rose madder, for the path. Rub off the masking fluid. Wet the area and drop in the pink over the entire path area. Mix the sky colours cobalt blue and rose madder and use this mix to indicate shadows.

26 Paint more shadows with the same sky colour with a little burnt sienna added. Soften them with a damp brush. Paint dappled shadows in the foreground using a no. 12 brush. Use burnt sienna and French ultramarine to shadow the dark side of the stone on the right-hand side.

27 Scumble darks at the right-hand edge of the path and in the foreground. After standing back to consider the result, I decided to add contrast between the canal and the path by darkening the water with brown and green right in the foreground.

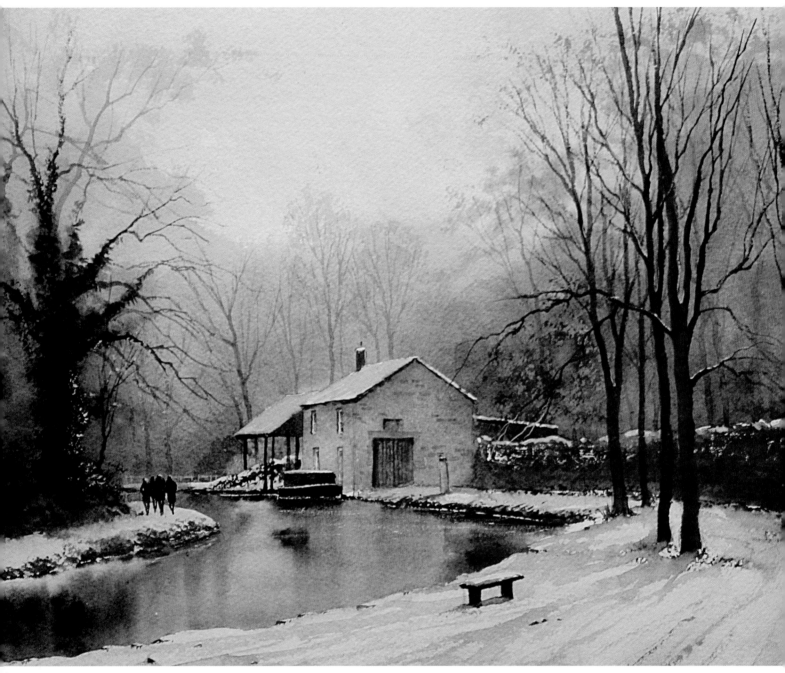

Winter's Day, Cromford Canal

355 x 280mm (14 x 11in)

This is Cromford Canal again – just a short distance further along the towpath from the subject of the project, in fact – but what a difference this makes. I took the photograph that I used as reference for this painting, during a walk along the canalside on a very cold New Year's Day. I remember that I was so inspired by the scene, I couldn't wait to get into the studio, and did the painting the next day.

I chose a cold palette with plenty of greys and wintery darks. I changed my usual choice of cobalt blue for phthalo blue, which is a slightly greener, cooler blue, and made grey by adding a touch of burnt umber. When I took the photograph, the sun was getting low, creating that soft pink glow in the sky, which I mixed using Naples yellow and a touch of rose madder.

Note how the bend in the canal allows it to disappear out of view, obscured by the large, dark, ivy-clad tree on the left. This tree, coupled with the large trees slightly further forward on the right, serve to frame the buildings which make up the centre of interest. It is also worth noting how I have used aerial perspective to good effect, by hinting at the distant trees with light grey mixes, which helps to create a slightly misty look.

Opposite:

Packhorse Bridge, Sutton on the Hill

508 x 406mm (20 x 16in)

In this scene I have used two methods to depict the reflections in the river. Those nearest to the bridge have been created using the same method as the main painting in this chapter, i.e. pulling down the colour with a flat brush to make the washes vertical. As the water gets nearer to the viewer, the gentle ripples disturbing the surface are more noticeable, so I have created a more broken look to the reflections. Note how the darker colour at the top of the sky is echoed in the water in the foreground, almost framing the scene. The contrast between the red-coloured bridge and the rich greens gives this painting good visual impact.

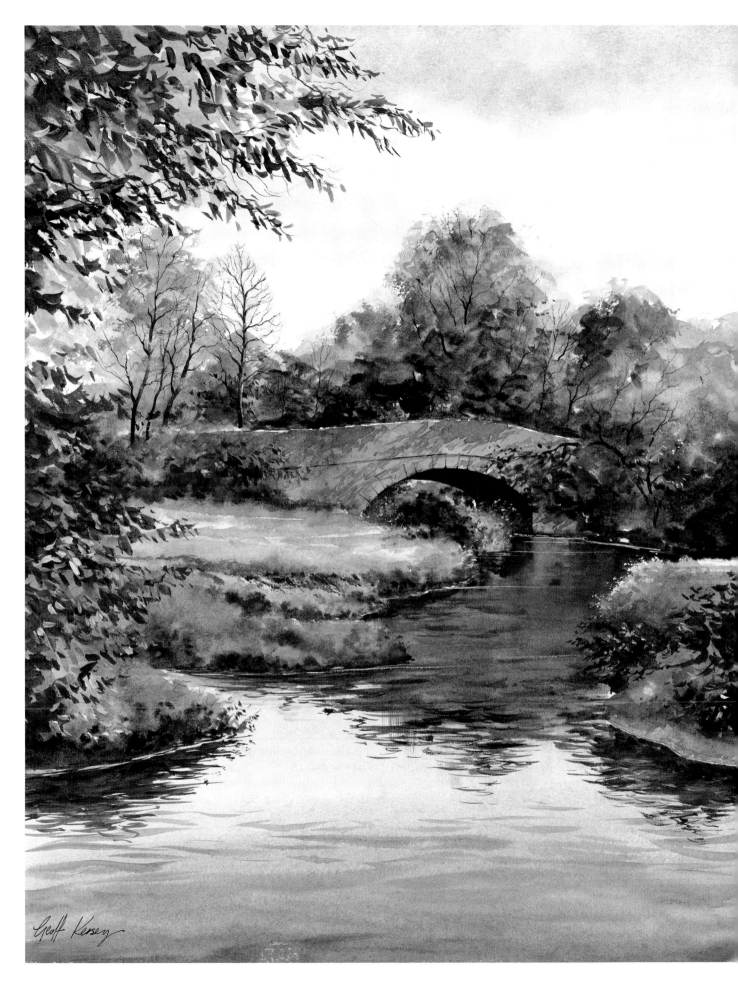

Geoff Kersey

Farm Buildings

I particularly enjoy this composition and have painted it many times. The farmer does not share my enthusiasm for the tumbledown old barn, looking forward to the day when it will be repaired, so I have made sure I have a collection of photographs and sketches.

Notice how you get just a glimpse of the distant woods on the slope, indicated in a soft violet that matches the sky. The shadows help the perspective on the road as well as adding warmth. Shadows should always be laid in thin transparent glazes, enabling the viewer to see a hint of the earlier washes underneath.

YOU WILL NEED

Rough paper, 460 x 350mm (18 x 13¾in)
Masking fluid
Naples yellow
Indian yellow
Cobalt blue
Rose madder
Burnt sienna
Aureolin
Raw sienna
Viridian
Burnt umber
Cerulean blue
Cobalt violet
French ultramarine
Cadmium red
White gouache
Lemon yellow
Old paintbrush
2.5cm (1in) flat brush
Large filbert wash brush
Round brushes: no. 6, no. 10, no. 12, no. 4
Kitchen towel
Tracing paper
Craft knife
Sponge

The finished painting

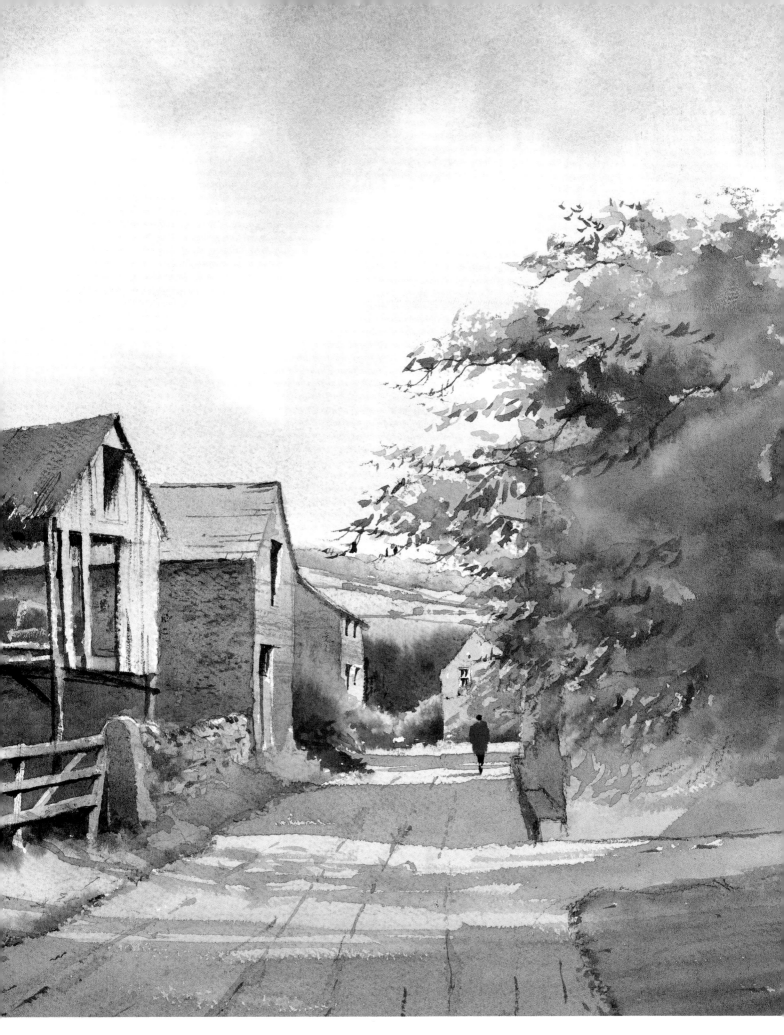

Source photographs

Here I have taken three portrait-format photographs and taped them together, providing me with a large image showing plenty of detail. Combining photos like this can give you more scope, creating longer format scenes with more opportunity to depict depth and distance.

I have a box overflowing with photographs stuck together like this, and while all the lines running down them and bits of tape holding them together mean that they do not look very attractive, they are packed with reference and information. It is possible to join the photographs seamlessly by using digital software to help, but ultimately the painting is the finished article, not the photograph. For this reason, I prefer to spend my time on the painting rather than the computer!

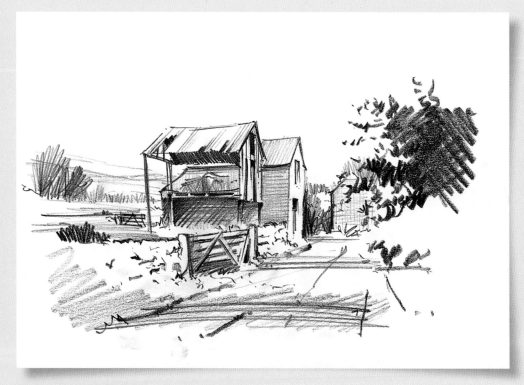

Preliminary sketch

Usually the sketch I make serves to simplify the scene to ensure I have a handle on the major elements, as to some extent this project is about detail. However, it is always worth doing a little thumbnail sketch prior to starting the painting, as it will help to give you a better understanding of the subject's composition and perspective. You can see that I decided to move the buildings a little further down the lane, allowing us a bit more of a glimpse of the landscape to the left and creating a sense of distance.

1 Sketch the scene and apply masking fluid to the tops of the roofs, the beams of the open-sided building, the gateposts and the top of the foreground wall.

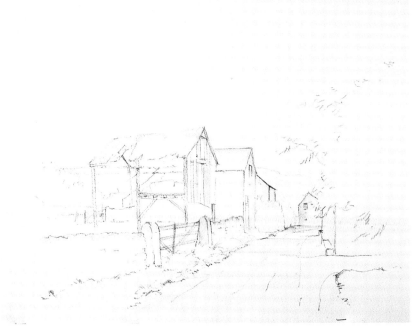

2 Mix the sky colours: Naples yellow and Indian yellow; cobalt blue and rose madder; cobalt blue, rose madder and a little burnt sienna. Wet the background using a 2.5cm (1in) flat brush, down to the masking fluid. Use a large filbert wash brush to paint a yellow glow at the bottom of the sky. Wash the brush and then add cobalt blue and rose madder at the top of the sky. Finally add cobalt blue, rose madder and burnt sienna to suggest a hint of cloud. Allow the painting to dry.

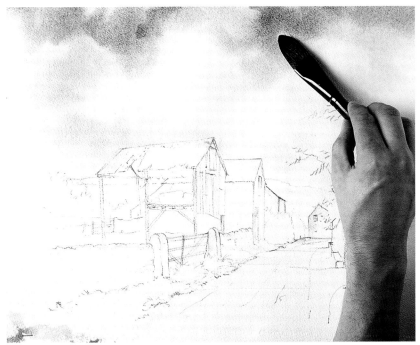

3 Use a wash of cobalt blue and rose madder for the distant bushes and trees. Soften their tops using a damp brush. Add a little burnt sienna to the mix to paint a darker colour at the base. Take these colours through to the other side of the barn.

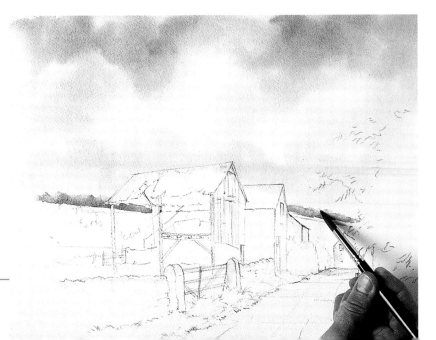

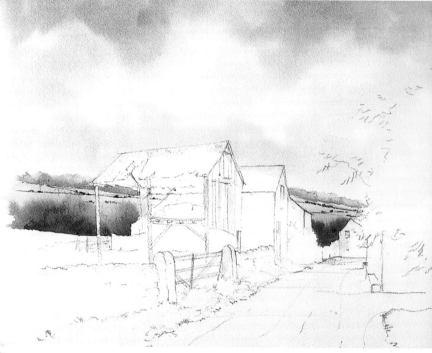

4 Mix aureolin and cobalt blue to make a green, brushing this in to indicate the land on the left. Paint the bush on the left by dropping in aureolin and cobalt blue mixed with burnt sienna. Continuing to paint wet into wet, drop in viridian and burnt sienna, which will create a dark to contrast with the top of the wall.

5 Continue with the same effects on the right of the painting, dropping in a touch of lemon yellow, then allow it to dry. Take a no. 6 brush and a mix of burnt sienna and cobalt blue and paint a suggestion of dry stone walls and hedges across the fields in the distance.

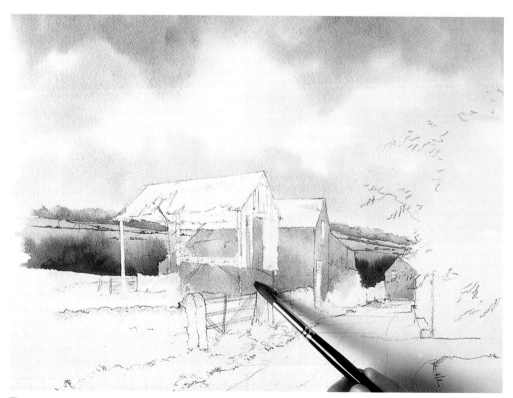

6 Remove all the masking fluid from the main building, but leave it on top of the wall. Apply a mixture of raw sienna and Naples yellow on to the building at the end of the lane, leaving spaces for windows. Paint the buildings on the left in the same way and soften the colour at the bottom. Painting wet in wet, add a pink mix of Naples yellow and rose madder over all the buildings, and drop in patches of burnt umber.

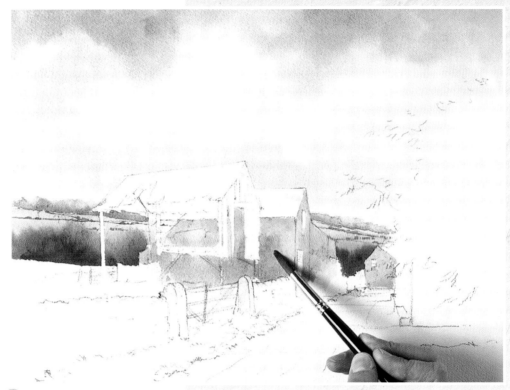

7 Drop in a touch of cerulean blue to create a warm grey here and there, then use a piece of kitchen towel to blot out the area of the left-hand building that will be covered by haystacks.

8 Add a mixture of cobalt blue, rose madder and burnt sienna for the darker colour in the stonework, and allow it to dry. Paint the light in the field on the left using Naples yellow and Indian yellow and a no. 10 brush, then add green mixed from aureolin and cobalt blue nearer to the top of the wall.

9 Drop the same green in behind the gate and soften it into the background. Mix a rich brown from burnt sienna and cobalt blue and paint this below the barn. Mix an even darker brown from burnt sienna and French ultramarine for areas of deep shadow.

10 Use the same dark brown under the guttering of the middle building. Paint raw sienna for the haystacks, leaving the white of the paper for the light catching the tops. Use cobalt blue and rose madder for the shadow on the haystacks.

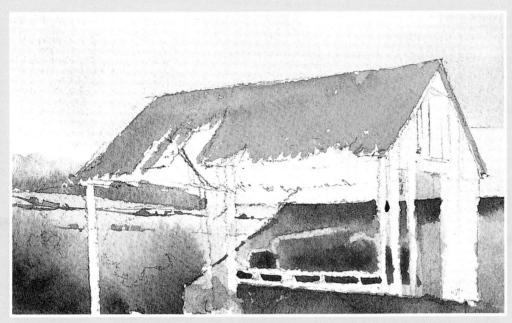

11 Paint the rusty roof of the barn using Indian yellow and cadmium red. Exaggerate the orange as it creates a good contrast with the sky. Leave a few very small patches of white paper to suggest the ragged, broken edge of the roof.

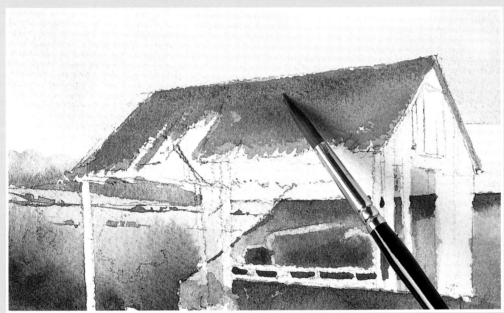

12 Drop in burnt sienna to deepen the colour of the rusty roof, then add cobalt blue and rose madder to darken it slightly. This should tone down the bright orange of the roof, but don't overdo it or you will lose that all-important feel of the sunlight catching the rusty roof.

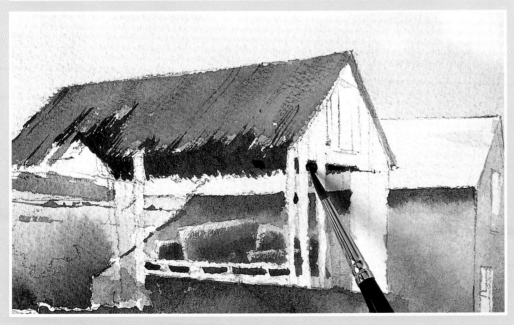

13 Mix white gouache and Naples yellow on a piece of scrap paper and use dry brush work to add a bit of detail to the haystacks. Mix a rich dark brown using burnt sienna and French ultramarine and paint the inside of the barn roof using a no. 12 brush. Fill in the shapes of the broken roof and very gently add a few fine lines to suggest the corrugation using a no. 4 brush.

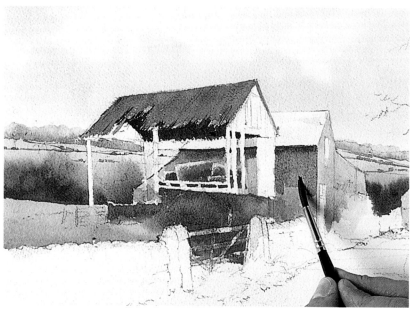

14 Wash the shadowed side of the barn with a thin glaze of cobalt blue and rose madder. Add burnt sienna to warm the bottom of the shadow for reflected light. Make sure this wash is not too strong so the transparency of the watercolour means that you can see through the shadow to the layers of wash underneath. Continue painting the shadow colours over the whole side of the building.

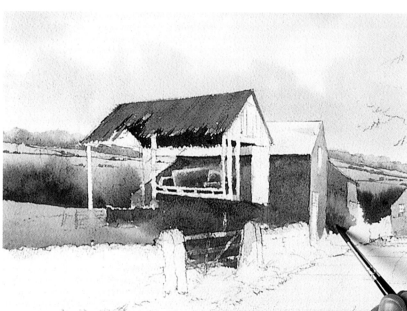

15 Intensify the shadows at the edges, against the light, to create contrast and form. Drop lemon yellow into the shadow of the second building from the right to suggest some foliage. Mix viridian, French ultramarine and burnt sienna to make green and drop this in with a no. 6 brush, allowing it to wander into the other colours to accentuate this bush shape.

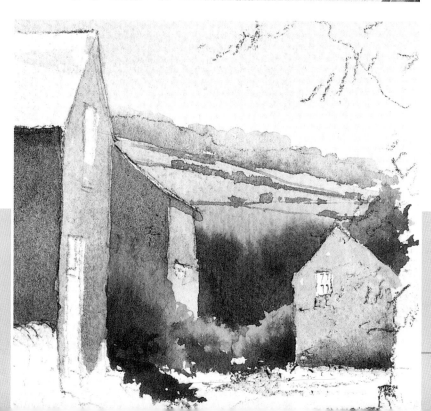

16 Paint a bush next to the cottage at the end of the lane in the same way: the darkness will help to pick out the lighter wall of the cottage. Darken the cottage near the ground by floating in a little shadow colour and allow to dry.

17 Rub the masking fluid off the barn and the gate. Paint a pale wash on the barn's woodwork of cerulean blue with a hint of green mixed from aureolin and cobalt blue. Paint the middle roof with the same green. Add a touch of cobalt blue and rose madder to hint that sky colours are reflected in the roof.

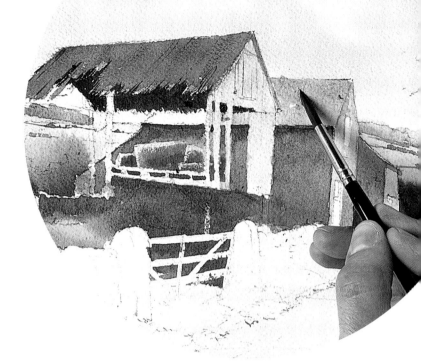

18 Mix a dark brown from burnt sienna and French ultramarine and use a no. 4 brush to paint the finer details on the barn. Use dry brush work and the same colour to paint the dark window-like hole at the top.

TIP

Fine details are most effective when 'drawn' with quick strokes of a fine brush.

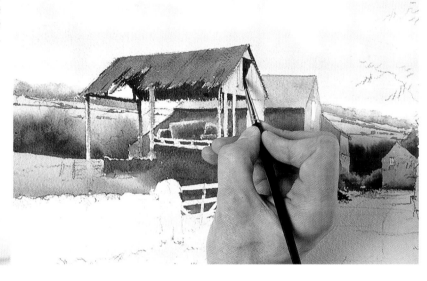

19 Continue painting details with the point of a no. 4 brush. Add shadows to the barn, leaving the uprights free of shadow where the sun shines. Paint in the distant five-bar gate on the left, supports under the hay loft and suggestions of slates on the middle roof. Paint the front door of the middle building with a drop of cerulean blue and then dark brown for the interior. Use the same dark brown to paint the top window and suggest the windows of the distant cottage.

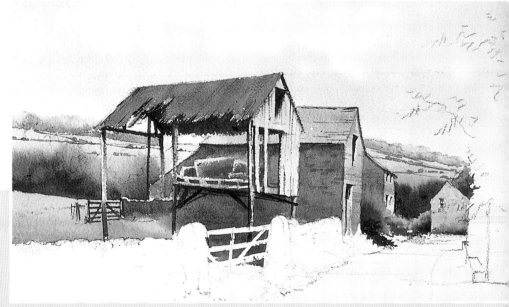

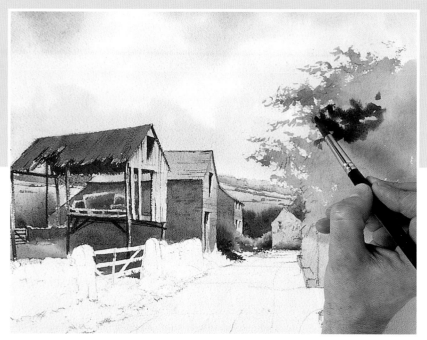

20 Paint the tree on the right with a glimpse of wall showing beneath it. Wash on the stone colour first, mixed from raw sienna, Naples yellow and Indian yellow. Then drop in the green, mixed from aureolin and cobalt blue. Use dry brush work to suggest foliage, and continue in this way with a darker green on top.

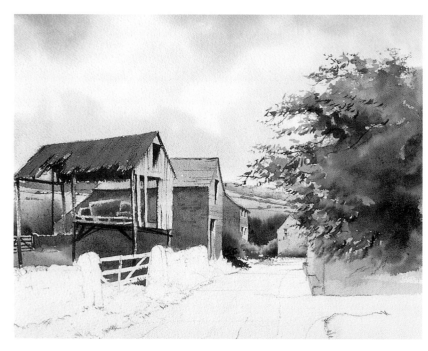

21 Mix a dark green from viridian, French ultramarine and burnt sienna and paint this on wet in wet. Use a no. 6 brush and aureolin mixed with cobalt blue to suggest leaves at the ends of the branches.

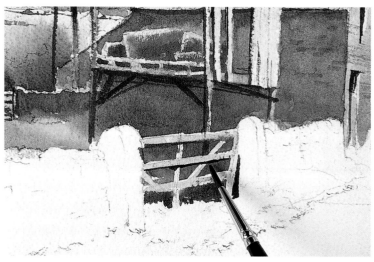

22 Paint the gate with a mix of cerulean blue, Naples yellow and Indian yellow, leaving a few glimpses of white paper to give the timber a washed-out look. Allow this to dry and then add a touch of detailing using burnt sienna mixed with French ultramarine.

23 Rub off the masking fluid from the wall. Now paint the wall and the grass verges together so that they soften into one another. Paint on a wash of raw sienna, leaving a glimpse of white at the top, and drop in green mixed from aureolin and cobalt blue, and then burnt sienna.

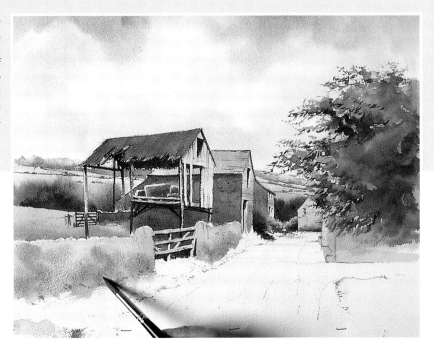

24 While the wall is still wet drop in some of the sky colour, cobalt blue and rose madder. Paint the grass using lemon yellow and green. Add more lemon yellow to make tufts, then raw sienna for warmth. Use the point of the brush to suggest the edge where the grass meets the lane. Keep this line irregular or it will appear as though the grass has been trimmed. Towards the foreground add dark green mixed from viridian, French ultramarine and burnt sienna for the roadside tufts of grass.

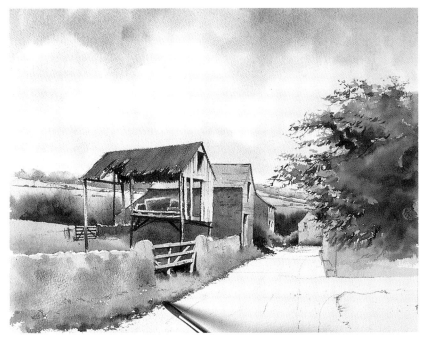

25 Dab the stone wall just before it dries with a piece of kitchen towel to create texture.

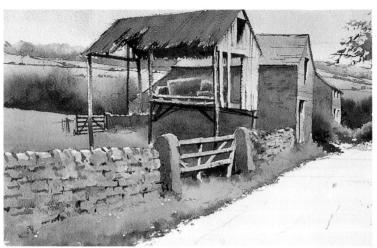

26 Work on the shape of the wall by adding shadow mixed from cobalt blue and rose madder. Shadow the gateposts and add a touch of burnt sienna to represent reflected colour. Use the point of a no. 12 brush to suggest the shape of stones and crevices. Vary the pressure you apply to create an irregular look to the crevices.

27 Continue working on the wall. Use cobalt blue and rose madder to darken some of the stones, and dry brush work to create texture. Paint the deepest crevices using burnt sienna and French ultramarine. Remember that the details should all be smaller when they are further away. Darken the bottom of the five-bar gate using the same dark brown, and soften the bottom edge.

28 Use dry brush work to paint the perspective lines of texture on the middle building.

29 Mix two washes for the path: Naples yellow with Indian yellow and cobalt blue with rose madder, reflected from the sky. Wash in the yellow colour from the top. Clean the brush and brush in the shadow wash on top. Wash from side to side with horizontal strokes to accentuate the flatness of the road. Allow the painting to dry.

30 Use a no. 10 brush and a mix of cobalt blue and rose madder to paint dappled shadows on the wall of the cottage at the end of the lane, and down the stone wall on the right. Paint cast shadows from the gate posts on the wall and gate. Paint a large shadow, as though from a tree, across the foreground to bring it forwards. Use the same shadow colour to paint perspective lines down the lane.

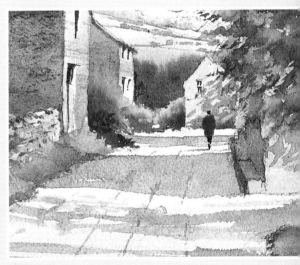

31 To place a figure, draw a simplified, tapering shape on a piece of tracing paper and try positioning it to see how it looks in the painting.

32 When you are satisfied with the placing of the figure, place the tracing paper on a cutting mat and cut out the shape of the torso using a craft knife. Place the tracing paper on the painting again and using it as a stencil, dab over it with a damp sponge to remove pigment.

33 Paint the figure in cadmium red, with burnt sienna and French ultramarine for the trousers. The feet should come to a point for a walking figure, or it will look as though the person is stationary. Add more dark for the head, leaving a gap for the collar, otherwise the figure may look hunched.

Old Woodshed, Sandringham Estate

318 x 230mm (12½ x 9in)

I discovered this tumbledown old wood store, just over the fence from a cottage I stay in when teaching at the West Norfolk Art Centre. When I spoke enthusiastically about it to the man who owns the cottage, I think I probably reinforced the notion that artists are a bit eccentric. I have exaggerated the warm colours, using plenty of burnt sienna and Indian yellow to try to create a soft glow. It is good fun to exaggerate the colours sometimes rather than trying to analyse and reproduce them exactly as they are. Of course you could come unstuck and overdo it, but take the risk – it's only a piece of paper.

Homestead, Estonia

457 x 305mm (18 x 12in)
One of my students brought along a photograph of this scene she had taken on holiday and I asked if I could use it. What appealed to me was the soft light and the tumbledown nature of the buildings, perfectly framed by the tall trees behind them.

Grange in Borrowdale

I have lost count of the amount of times I have painted this beautiful scene in the Lake District. I love the way it changes so much with the seasons and the way the steep hillside in the background focuses our attention on the bridge and cluster of buildings.

YOU WILL NEED

Rough paper, 560 x 380mm (22 x 15in)
Masking fluid
Naples yellow
White gouache
Light red
Cobalt blue
Rose madder
Raw sienna
Burnt sienna
Lemon yellow
Aureolin
French ultramarine
Cerulean blue
Phthalo blue
Old paintbrush
2B pencil
Putty eraser
Soap
12mm (½in) flat brush
Round brushes: no. 16, no. 8, no. 6, no. 4, no. 2
Kitchen towel

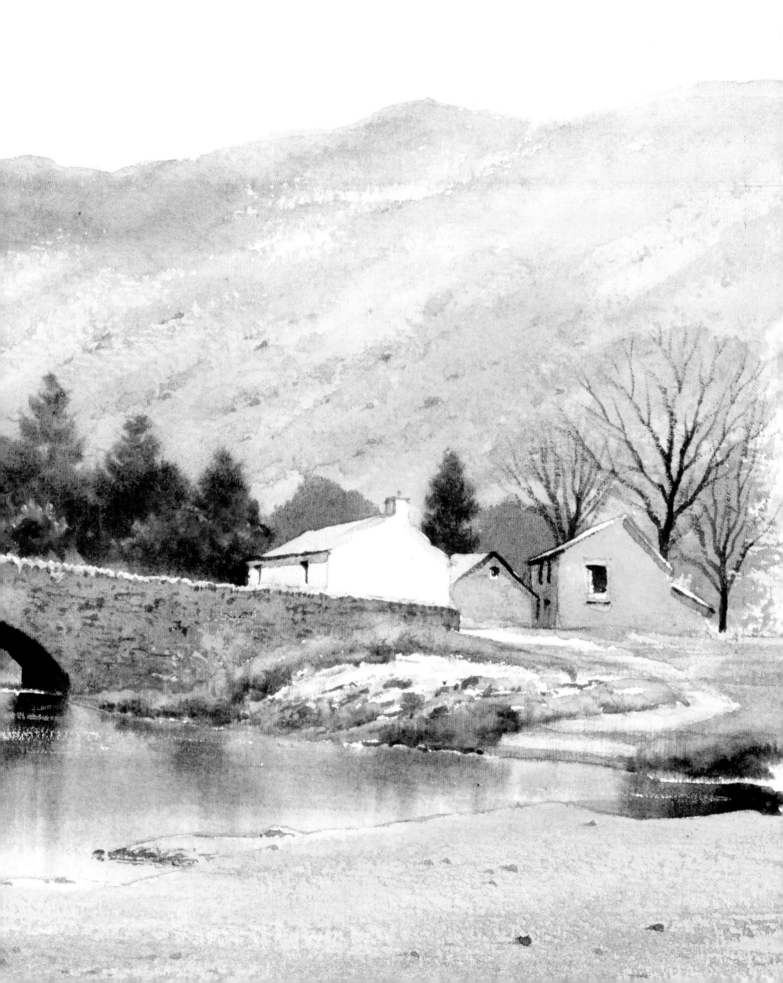

Source photograph

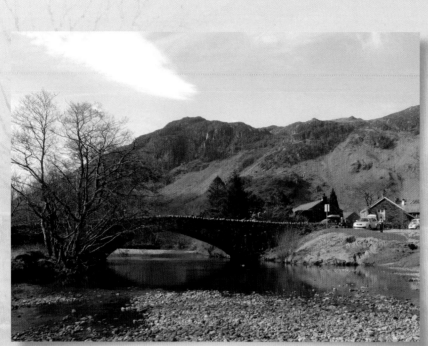

This photograph is a little dark, but it still has plenty of information from which to construct the painting, showing the foreground banks and tree, the midground bridge and buildings, and the distant hillsides. As long as your photograph shows the main elements in sufficient detail, it can serve as a source of reference – the rest is up to your painting.

Preliminary sketch

Here, the photograph has been used to inform the sketch, which I have used to explore changes to the subject, such as adding more light on the hills and the bridge to emphasise their importance to the composition.

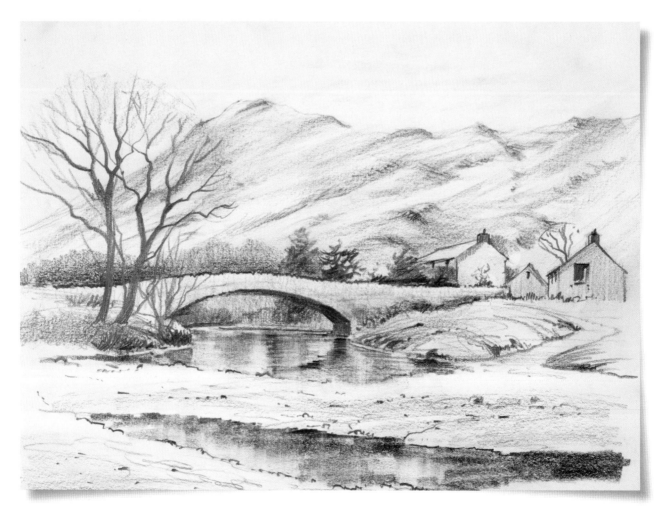

1 Use a 2B pencil to draw in the basic shapes. Use a putty eraser to soften and knock back the lines in the distance, then apply masking fluid generously to the roofs and sides of the midground buildings. Use slightly rough strokes to avoid it looking smooth and modern. Mask the arch of the bridge, including the underside, in the same way. Use finer, longer strokes for the trees and the shingle bank in the foreground.

2 Prepare a peach mix of Naples yellow and light red, and dilute to a watery consistency. Prepare a second wash of cobalt blue, and a grey mix of cobalt blue and rose madder with a touch of light red. Next, use a damp natural sponge to wet the whole sky, working over the top of the hill too. Use the no. 16 brush to apply the peach mix over the lower part of the wet area.

3 Rinse the brush. Pick up cobalt blue and work wet-into-wet down from the top of the painting into the sky area using the side of the brush. This allows you to cover the sky quickly. While the paint remains wet, touch in some of the grey mix across the top if the sky. Let the whole sky dry completely before you continue.

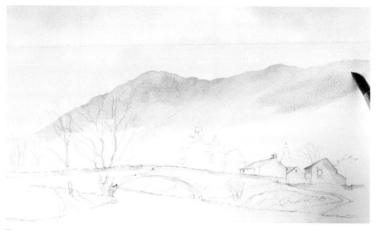
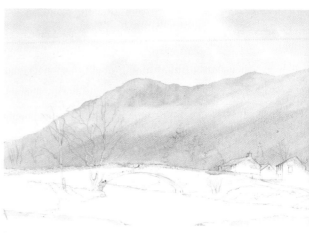

4 Create a second grey mix of cobalt blue and rose madder with a touch of light red, making it stronger in tone this time by diluting it less. Make a sandy mix of raw sienna and burnt sienna, and a light green mix from aureolin and cobalt blue with a hint of light red. Finally, create a fairly thick mix of dark green from phthalo blue, burnt sienna and a little light red. Using the no. 16 round brush, apply cobalt blue to the crest of the hill. Touch in a little of the dilute grey mix to vary the hue.

5 Continue laying in colour on the hill, introducing the sandy mix about halfway down, and the light green mix at the base. Use strokes that describe the slope of the hill.

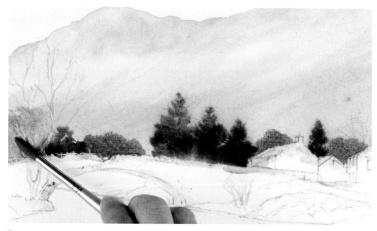
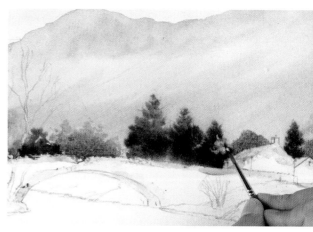

6 Drop in the fir trees while the paint remains damp using the tip of the no. 8 brush and the dark green mix. Ensure the trees taper away to a point at the top. Use the stronger grey mix to add darker shapes between the groups of trees, applying the paint with the side of the brush to ensure softness.

7 Pick up neat lemon yellow on the tip of a no. 4 brush and touch in details at the base of the fir trees while they remain wet. This suggests smaller bushes in front of the firs.

8 Fill in the area beneath the bridge with the light green, sandy and dilute grey mixes, applying the paint with the no. 8 brush. Change to the no. 4 brush and work the dark green mix down to the waterline, adding pure lemon yellow wet-in-wet as highlights.

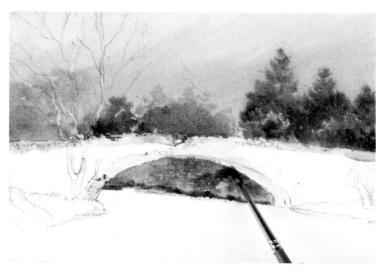

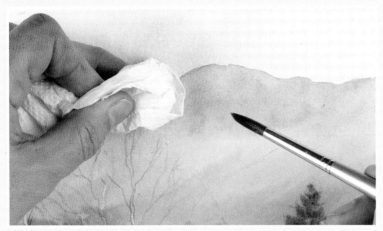

9 Wet a no. 8 brush. Run it over a small area of the crest of the hill. Gently wipe the water away with clean kitchen paper, working downwards with the hill. This will soften the crest of the hill.

10 Load the no. 6 brush with the light grey mix and draw the side of the brush over the hillside. This dry brush technique catches the raised texture of the paper surface, creating texture on the hill. Reinforce the angle of the slope using the dark grey mix in the same way.

🔘 TIP

Hold the brush with the thumb on one side and all four fingers on the other.

11 Suggest detail lower down the slope by using the point of the no. 2 brush to pick out and emphasise parts of the texture suggested by the dry brush technique. While we do not want to pick out every boulder and bit of scree, strengthening some helps to suggest detail. Use the darker grey mix for these details and lift the brush off to the lower left. This gives a 'dash' of shadow to each boulder.

12 Use a no. 8 brush to paint the foliage area around the wintry trees on the right-hand side of the painting using the side of the brush. Aim to create a loose, broken semi-circle that extends between the ends of the tree branches.

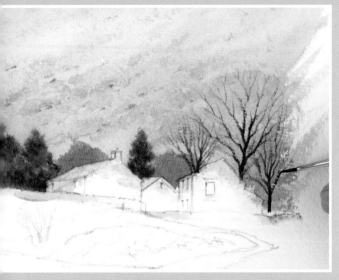

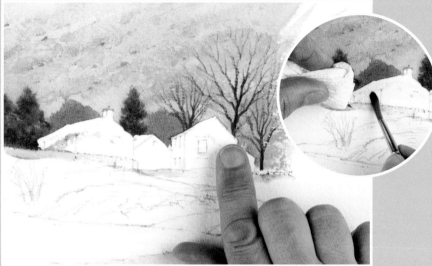

13 Once the foliage on the right-hand side group of trees is bone dry, mix burnt sienna with French ultramarine to make a thick mix. Starting from the base of each tree, use a no. 2 brush to paint in the trunk and work up to the tips of the branches, keeping them within the edges of the foliage colour. The stroke will naturally taper off as the brush runs out. Use light, flicking strokes to avoid leaving a blob at the end of each branch.

14 Allow the trees to dry, then use a clean, dry finger to remove the masking fluid from the buildings, leaving it in place on the bridge. If any paint has got onto the buildings themselves, wet it and lift it away with clean kitchen paper (see inset).

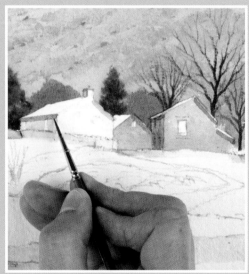

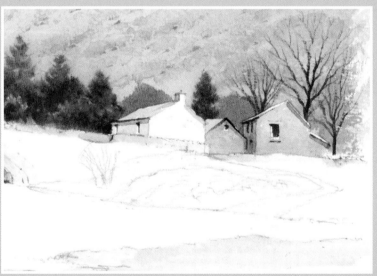

15 Use a no. 4 round brush to paint the parts of the building in shadow with dilute cobalt blue, leaving the windows white. Create a slate-coloured mix of raw sienna with a hint of cerulean blue. Paint the other buildings with a dilute version of this mix. Drop in a shadow mix of cobalt blue and rose madder at the bases for interest and texture. Allow the buildings to dry, then develop the shadows with glazes of the shadow mix.

16 Use the shadow mix to paint the top of the roof and below the eaves of the left-hand building. Change to the dark mix (French ultramarine and burnt sienna) and pick out details like the edge of the shutters and the windows on all the buildings. Make the windows appear recessed by painting the top and right-hand sides, leaving the bottom and left-hand sides clean.

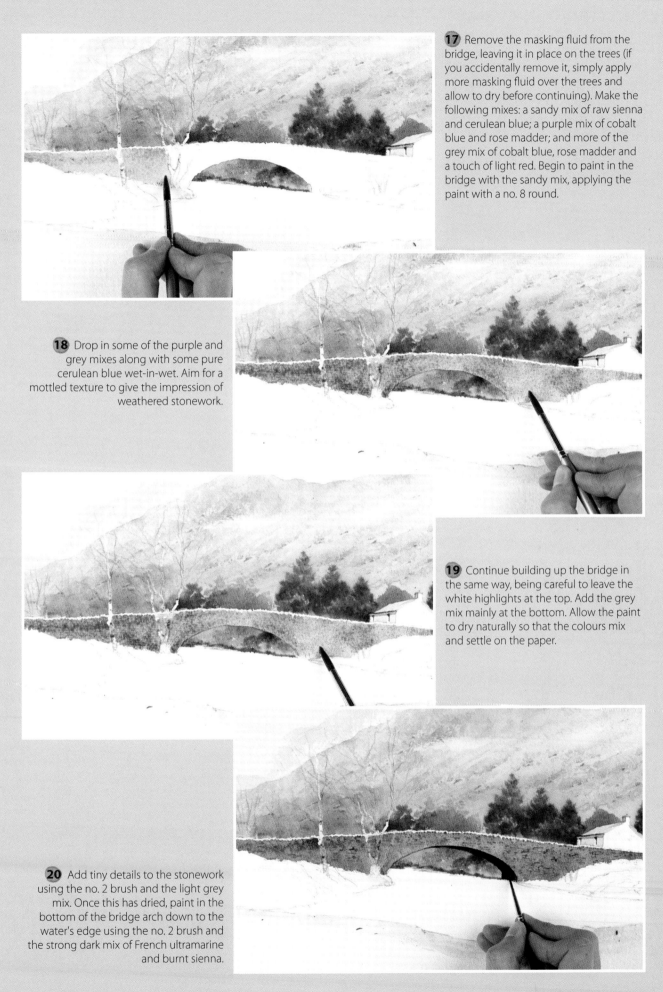

17 Remove the masking fluid from the bridge, leaving it in place on the trees (if you accidentally remove it, simply apply more masking fluid over the trees and allow to dry before continuing). Make the following mixes: a sandy mix of raw sienna and cerulean blue; a purple mix of cobalt blue and rose madder; and more of the grey mix of cobalt blue, rose madder and a touch of light red. Begin to paint in the bridge with the sandy mix, applying the paint with a no. 8 round.

18 Drop in some of the purple and grey mixes along with some pure cerulean blue wet-in-wet. Aim for a mottled texture to give the impression of weathered stonework.

19 Continue building up the bridge in the same way, being careful to leave the white highlights at the top. Add the grey mix mainly at the bottom. Allow the paint to dry naturally so that the colours mix and settle on the paper.

20 Add tiny details to the stonework using the no. 2 brush and the light grey mix. Once this has dried, paint in the bottom of the bridge arch down to the water's edge using the no. 2 brush and the strong dark mix of French ultramarine and burnt sienna.

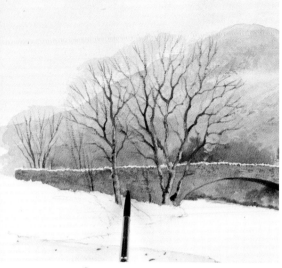

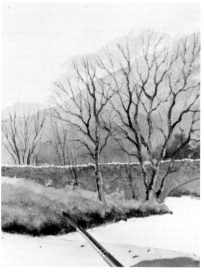

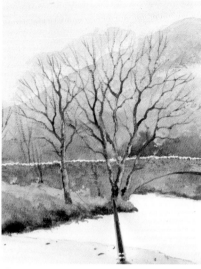

21 Once the bridge has dried, remove the masking fluid from the trees on the left-hand side. Prepare the following mixes: a light mix of raw sienna and burnt sienna, and more of the dark mix. Apply the light mix using the no. 4 brush over the lower trunk. Add in touches of the dark mix to the left-hand side using the no. 2 brush to suggest shadow. Extend the dark mix into the upper branches.

22 Mix a grass green from aureolin and cobalt blue with a hint of raw sienna, and a dark green from phthalo blue and burnt sienna. Using the no. 8 brush, dampen the base of the bridge with clean water, then paint in the grassy area with the grass green mix. Vary the hue with raw sienna and neat lemon yellow. Extend the colour down to the water's edge, then drop in the dark green at the edge using a no. 6 brush.

23 Use a no. 6 brush loaded with grass green to encourage the wet colours at the bases of the trees to mix and soften into the bank.

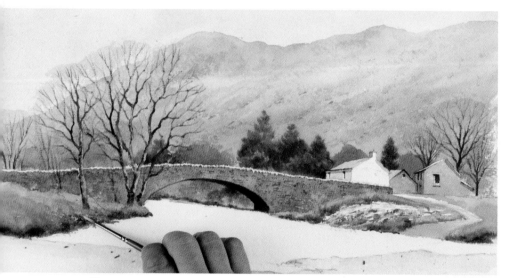

24 Paint the bank on the right-hand side of the painting in the same way, leaving the path clean and adding the rocky outcrop with a no. 4 brush and the light mix of raw sienna and burnt sienna. Touch in a little of the purple mix (cobalt blue and rose madder), then add dark touches with a dark grey mix of cobalt blue, rose madder and burnt sienna. Once dry, touch in details on both banks and the bridge using the dark grey mix and a mix of lemon yellow and Naples yellow. Use the tip and side of the brush for a variety of textures.

25 Still using the no. 4 brush, add subtle shadow areas across the path and grass with the purple mix.

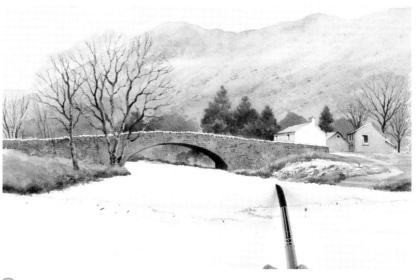

26 Prepare the following mixes: cobalt blue; a purple mix of cobalt blue, rose madder and burnt sienna; raw sienna and cerulean blue; a sandy mix of raw sienna and light red; a grass green mix of aureolin, cobalt blue and a hint of raw sienna; a dark green mix of phthalo blue and burnt sienna; and a dark mix of burnt sienna and French ultramarine.

27 Wet the whole river using clean water and the no. 16 brush, leaving a tiny gap of clean dry paper between the wet area and the river bank. Paint the river with broad strokes of cobalt blue.

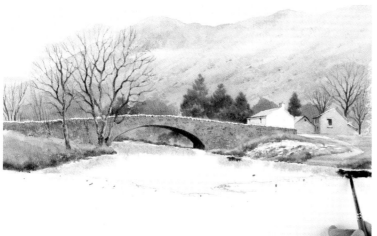

28 Drop in the other mixes wet-in-wet, using the existing paint on the land to guide your placement; adding the grass green mix below the grassy areas, for example.

29 Change to a no. 2 brush to add the darker reflections of the bridge and foreground, again mirroring the shapes on the land.

30 Wet a 12mm (½in) flat brush, squeeze out the excess water and then lightly draw the damp tip directly downwards over the wet paint to gently blur the colour.

31 While the paint is still wet, create ripples in the river by adding fine horizontal touches with the no. 2 round. Use it dry, to lift out a little wet colour.

32 Allow the river to dry completely, then use the no. 2 brush to add a few horizontal strokes of white gouache to suggest highlights on the ripples. Apply these sparingly – aim for a subtle effect. Allow to dry thoroughly.

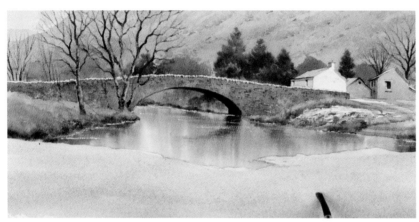

33 Rub away the remaining masking fluid, and a damp sponge to gently rub away any stray paint strokes in the foreground. Paint the shingle bank using a no. 10 brush and the sandy mix (raw sienna and light red), adding a touch more burnt sienna towards the bottom of the paper. While the paint is wet, add a little of the dilute purple mix (cobalt blue, rose madder and burnt sienna) at the very bottom. This will mix with the colour on the surface to make a warm grey.

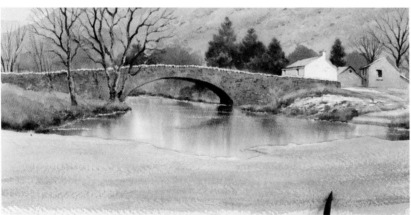

34 Allow the painting to dry, then clean and dry a no. 10 brush. Use the dry brush technique with the purple mix over the shingle. Add more cobalt blue and burnt sienna to turn the purple mix into a dark grey mix and repeat the process.

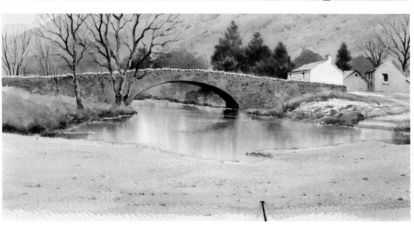

35 Using the dark grey mix, pick out details with the point of the no. 2 round. Vary the hue and add interest using the dark mix (burnt sienna and French ultramarine). Refine the shapes suggested by the dry brush effect, by adding shadows to lighter areas. Make the pebbles larger towards the foreground.

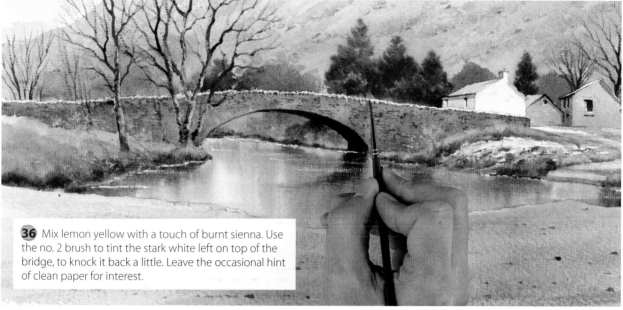

36 Mix lemon yellow with a touch of burnt sienna. Use the no. 2 brush to tint the stark white left on top of the bridge, to knock it back a little. Leave the occasional hint of clean paper for interest.

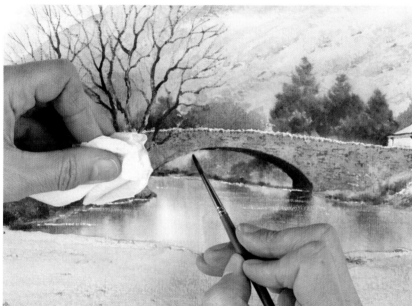

37 Let the painting dry, then look to see if anything needs adjusting. Here, the bridge is too close in colour to the background beneath it. Wet the background with a no. 2 brush and clean water, and lift a little paint away with clean kitchen paper.

38 Allow the background to dry, then strengthen the bridge with subtle touches of the purple mix to finish.

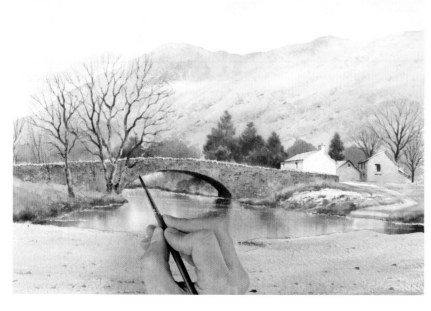

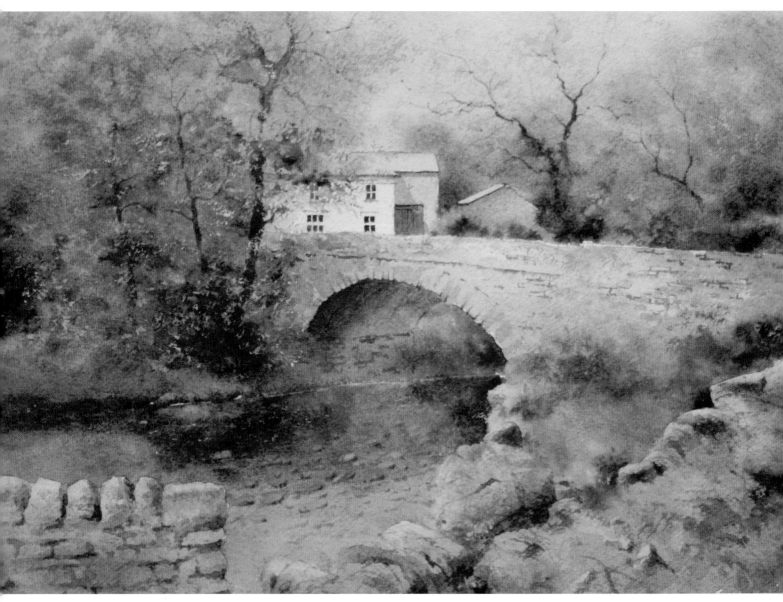

Elterwater Bridge, Cumbria

380 x 280mm (15 x 11in)

I love painting bridges – in all shapes and sizes – and the Lake District, UK, has more than a thousand to choose from, making it a rich resource. I am by no means alone in choosing bridges as painting subjects, as any visit to an art club or art society's annual show will prove.

This is not an obvious subject for illustrating depth and distance as we don't see much further than the trees just beyond the far river bank, but I particularly like the way we glimpse the whitewashed cottage at the far side of the bridge, partially obscured by the tree foliage. It was important here to not over-detail the buildings, as that would have brought them forward, making them appear almost as though they were sat on the bridge, rather than beyond it.

I particularly enjoyed the challenges presented by the bridge itself. It is worth noting that I have used a cooler, more blue, green for the trees on and beyond the opposite bank, which contrasts with a really bright glow in the centre. I have tried to draw the viewer into the scene with the partially hidden cottage featuring cool blue shadows. The larger foreground rocks, and hint of a warm orange colour in the foreground greens, further confirm the feeling of distance.

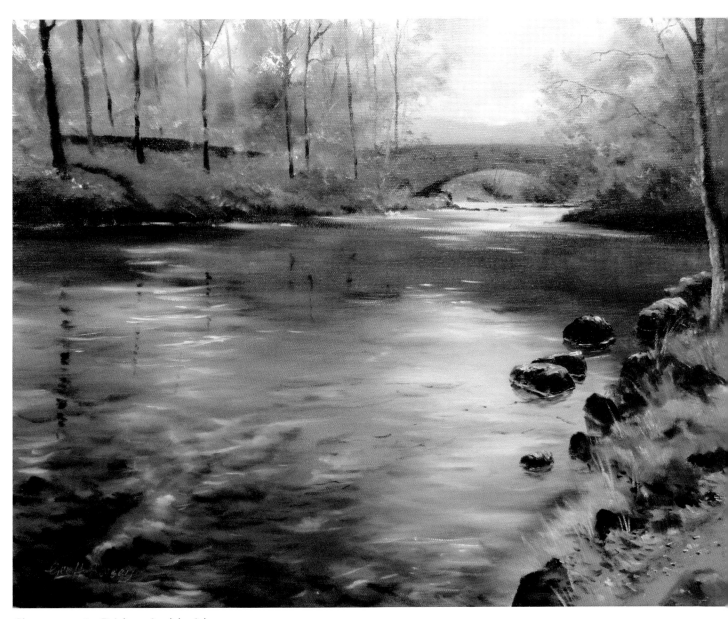

Clappersgate Bridge, Ambleside

710 x 460mm (28 x 18in)

I have chosen quite a low viewpoint for this example, pushing the bridge up into the top third of the scene, and rendering it quite small. Despite this, the bridge remains the focal point, and again the composition makes good use of linear perspective. The far bank on the right, topped by a glimpse of drystone wall, the foreground bank and the line of partially submerged stones, all serve to direct the viewer to this focal point. Note also how the glimpse of distant hill is such a light tone and a cool grey colour, which serves to create aerial perspective.

This example is in fact an oil painting, but I have included it because the methods used to create a feeling of depth in a painting are the same across all media. I particularly enjoyed putting in the splashes of orange and yellow foliage, which contrasts well with the deep blue in the water.

Baslow Edge

Baslow Edge is part of a gritstone escarpment that runs through the Peak District National Park, near my home in Derbyshire. It has been an excellent source of painting subjects for me over the years, and presents a good opportunity to describe a sense of distance.

YOU WILL NEED

Rough paper, 560 x 380mm (22 x 15in)
Masking fluid
Cerulean blue
Cobalt violet
Naples yellow
Rose madder
Light red
Aureolin
Cobalt blue
Raw sienna
Phthalo blue
Burnt sienna
Old paintbrush
2B pencil
Putty eraser
Soap
Round brushes: no. 16, no. 10, no. 8, no. 6, no. 4, no. 2
Kitchen towel
Sponge

The finished painting

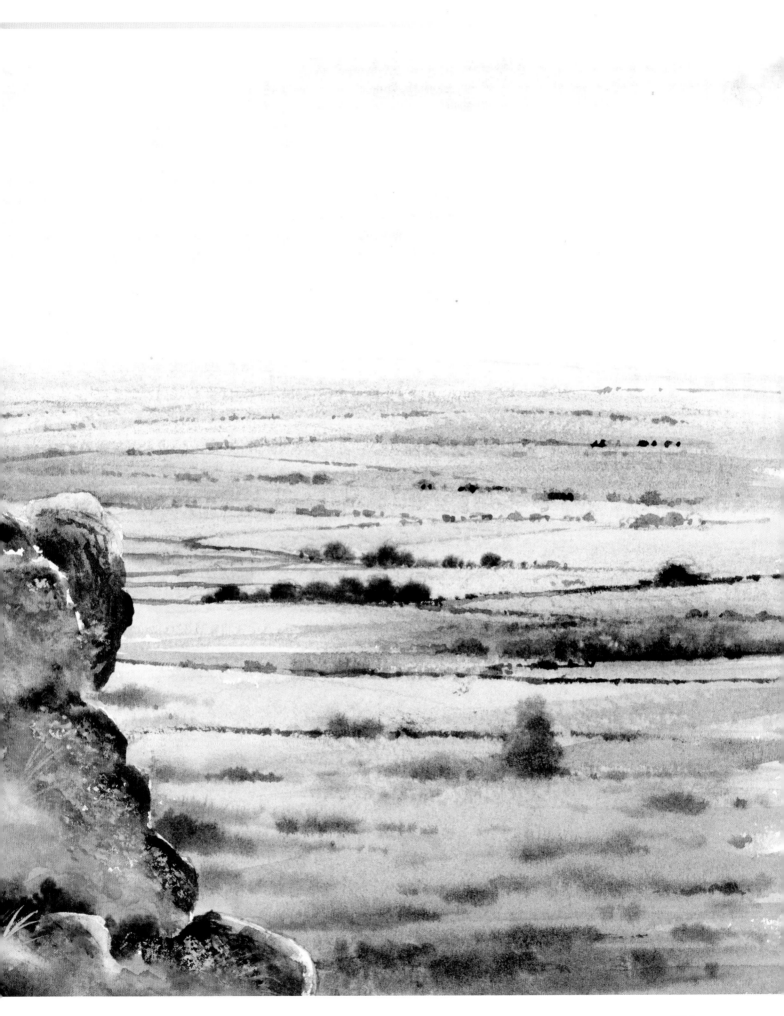

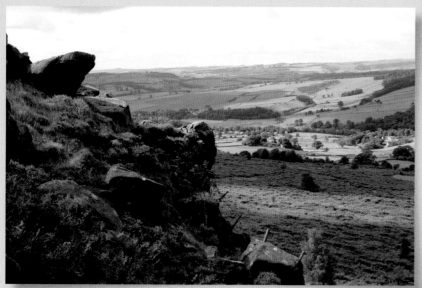

Source photograph

I particularly like the way the hard, tactile shapes of the rocks and boulders in the foreground intermingle with the soft shapes of the grasses and heathers. Note how the hard diagonal of the escarpment provides a constant foreground contrast with the receding ground, which fades into grey-blue in the distance.

Preliminary sketch

This sketch simplifies the scene by removing excess detail without compromising the essential split between foreground and distance. The distant foliage is dotted with trees that get smaller as the ground recedes – a neat way to reinforce the sense of distance.

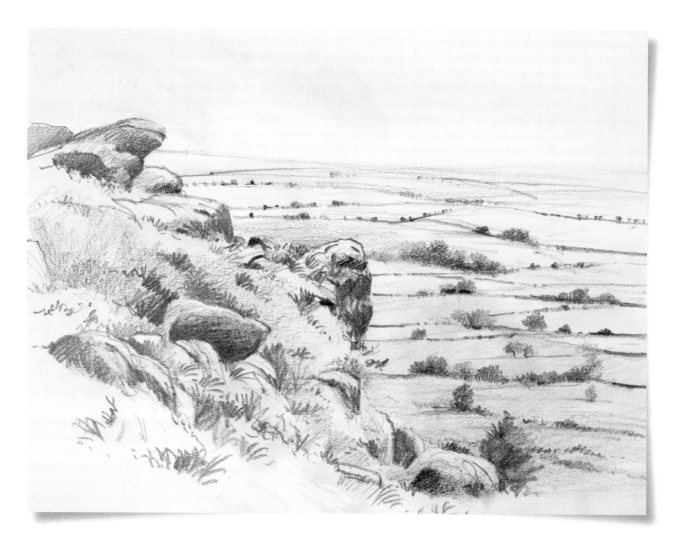

1 Sketch out the basic shapes using a 2B pencil, then soften the distant lines using a putty eraser. Apply masking fluid as shown, using the old paintbrush.

2 Make a blue-grey mix of cerulean blue and cobalt violet; a peach mix of Naples yellow and rose madder; and some pure cobalt blue. Wet the sky area using clean water and a sponge, working right over the rocks and horizon line. Use a no. 16 brush to lay in the peach mix with horizontal strokes, then drop in horizontal streaks of cobalt blue wet-in-wet, from the top down to halfway down the house.

3 While the paint remains wet, use the side of a no. 10 brush to suggest clouds with the blue-grey mix. Allow to dry completely before continuing.

4 Prepare the following wells of paint: a sandy mix of Naples yellow and light red; a grass green mix of aureolin, cobalt blue and a touch of raw sienna; a blue-green mix that uses the same colours as grass green, but with more cobalt blue and less dilute; and a dark green mix of phthalo blue and burnt sienna.

5 Using the no. 16 brush, lay in cobalt blue touches across the horizon, then introduce blue-grey (cerulean blue and cobalt violet) wet-in-wet. Continue working forward, adding blue-green, then the sand mix, still working wet-in-wet.

6 Add touches of the grass green and sand mixes to create a variegated wash to suggest different fields in the foreground, midground and background. Increase the size of the brush strokes you use as you pass the halfway mark towards the bottom of the painting.

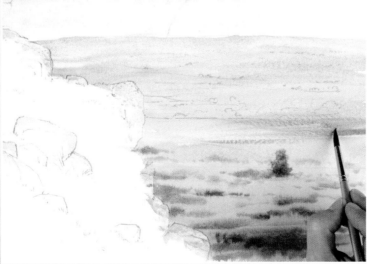

7 Change to the no. 8 brush and introduce touches of the dark green mix wet-in-wet to represent trees and hedgerows. Start at the bottom of the paper and work back upwards. Keep the marks relatively small to create distance.

8 Add streaks of the blue-green and blue-grey mixes halfway back to the horizon. While the paint remains wet, add tiny touches of the dark green mix using the tip of the no. 4 brush to suggest distant trees and hedgerows. Keep these details much smaller than the foreground details.

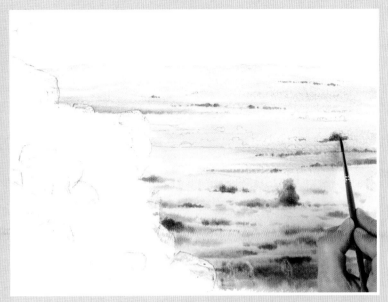

9 Wet the hill crest with a clean damp brush and use kitchen paper to lift away a little of the paint here. This softens the line of the horizon.

10 Using a mix of cobalt violet, cerulean blue and light red, suggest shadows on the distant fields with sweeping strokes of the no. 10 brush.

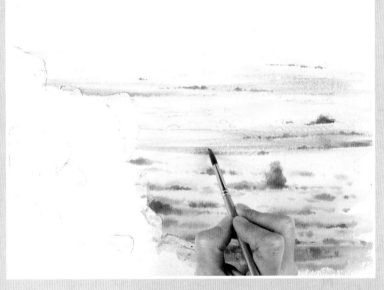

11 Change to the no. 2 brush and add tiny touches of the dark green mix (phthalo blue and burnt sienna) in the background. The tiniest touch can suggest a hedgerow or tree this far in the distance. Change to the shadow mix of cobalt violet, cerulean blue and light red to add dry stone walls in the middle distance.

12 Still using the no. 2 brush, strengthen the walls nearer the foreground with a dark mix of burnt sienna and cobalt blue. Use slightly larger marks as you advance towards the bottom of the paper. Wet a no. 8 brush and dampen the larger trees in the middle distance. 'Float in' the dark mix by loading the no. 2 with the paint and touching the wet area. As the paint dries the colour will settle softly, creating the effect of distant foliage. Allow to dry completely before continuing.

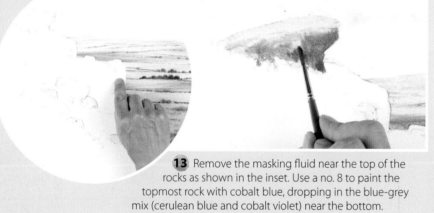

13 Remove the masking fluid near the top of the rocks as shown in the inset. Use a no. 8 to paint the topmost rock with cobalt blue, dropping in the blue-grey mix (cerulean blue and cobalt violet) near the bottom.

14 Add light red to the blue-grey mix and strengthen the main shadow areas on the rock, before softening the base of the rock with lemon yellow, raw sienna and a mix of cobalt violet and light red.

15 Use the same colours and mixes to develop the area around the top rock with the no. 4 round brush.

16 Change to the no. 2 round brush and continue painting in the other rocks. Leave a fine white edge of clean paper at the top of each large stone as you paint them in using the mix of light red and cobalt violet, dropping in the blue-grey mix.

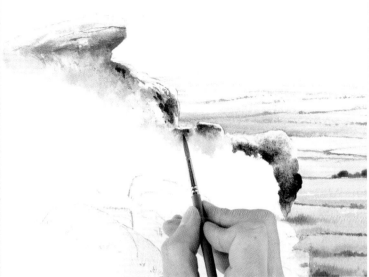

17 Build up the grass around the rocks, using lemon yellow and the grass green mix to create a variegated effect. Once dry, create sharp textures on the rocks using the tip of the no. 2 brush and a mix of cerulean blue, cobalt violet and light red. Add just a few crevices and fissures.

18 Change to the no. 6 brush to paint in the rocks on the edge of the cliff using the pink mix of cobalt violet and light red. Add in cobalt blue and the blue-grey mix wet-in-wet. While those remain wet, add very strong darks with a mix of French ultramarine, burnt sienna and rose madder. Extend these touches back into the more distant rocks so there is not an obvious difference in approach.

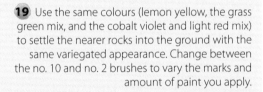

19 Use the same colours (lemon yellow, the grass green mix, and the cobalt violet and light red mix) to settle the nearer rocks into the ground with the same variegated appearance. Change between the no. 10 and no. 2 brushes to vary the marks and amount of paint you apply.

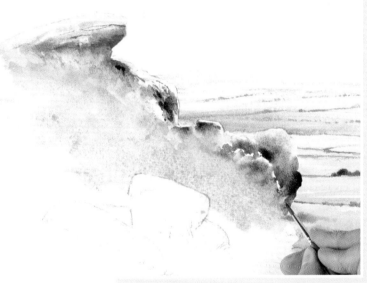

20 Continue building up the grassy area with the grass green mix and the dark mix of French ultramarine and burnt sienna. Touch in neat lemon yellow to prevent the dark areas looking flat. Develop the texture on the rocks using the tip of the no. 2 brush and the dark mix of burnt sienna and French ultramarine.

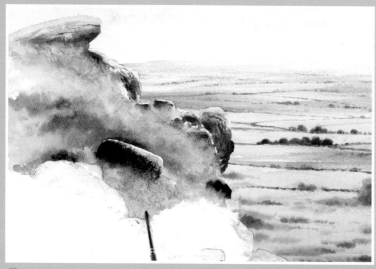

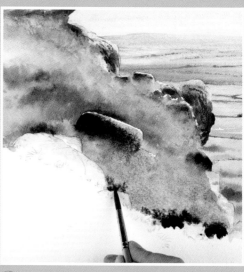

21 Once dry, remove the masking fluid from the central rocks and paint them in using the colours and techniques in step 18. While the rocks are wet, develop the grass around them using the colours and techniques in step 19. Work down towards the foreground, adding warmer colours such as raw sienna wet-in-wet as you advance.

22 Use the no. 8 brush to drop touches of the dark green mix (phthalo blue and burnt sienna) into the wet paint above and around the remaining masking fluid.

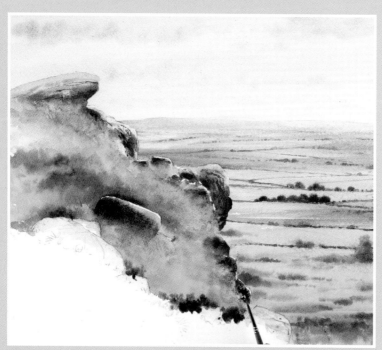

23 Remove the masking fluid from the rocks on the right-hand edge of the cliff, then re-wet the grass area at the border of the rock using the no. 6 brush. The cliff edge allows you to paint in rocks like these while the paint below dries, because this part is surrounded by dry paint. Add lemon yellow to help blend the colours of the rocks and grass.

24 Mix cobalt violet with white gouache. Pick it up on a dry no. 2 brush and touch the side to the paper surface to create the base for heather.

25 Continue building up the heather across the grassy area. The effect is very striking against dark rocks. Add detail to the flowerheads with the tip of the no. 2 brush and the mix of cobalt violet and white gouache.

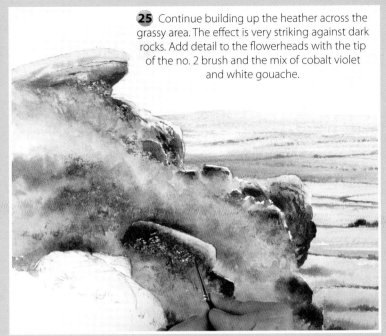

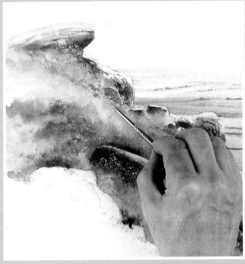

26 Add hints of lemon yellow with the side of the no. 2 brush and the dry brush technique. Allow the painting to dry before continuing.

27 Use the no. 8 brush to paint in the rocks on the lower left-hand side in the same way as the other rocks, then extend the grass down to the bottom of the paper. Add more raw sienna, burnt sienna and aureolin so that the foreground is warmer and brighter than the more distant grass.

28 Using a no. 10 round brush, re-wet the lowest part of the grass and drop in a dark mix of French ultramarine, burnt sienna and rose madder, then add a mix of phthalo blue and burnt sienna wet-in-wet to add deeper darks.

29 Allow the dark mix to dry, then appraise the painting. Soften any edges that are too hard on the rock highlights using a wet no. 4 round brush.

30 Add detail and texture to the rocks with a no. 2 round, touching in cracks and fissures with a dark mix of French ultramarine, burnt sienna and rose madder.

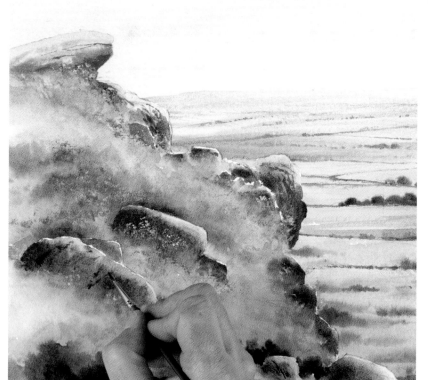

31 Add more heather touches with the mix of cobalt violet and white gouache. Use the side of the no. 4 brush instead of the no. 2 brush to create larger marks in the foreground. Use a mix of rose madder and white gouache for variety.

32 To finish, add some larger flowerheads in the foreground, using the no. 2 brush and the same two pink mixes.

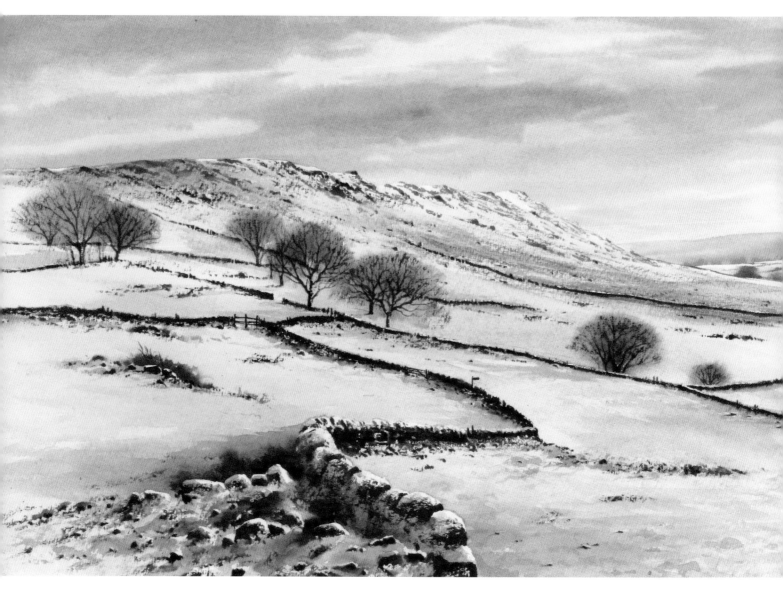

Winter on Baslow Edge

660 x 460mm (26 x 18in)

I often like to re-visit the same scene in a different season. The difference (particularly between winter and summer) is often amazing. Here I have not only chosen a different season but also a totally different viewpoint; coming down the hill from the edge and looking up at it. This totally changes the composition, with the snow-covered hills tinted by cool blue-grey shadows, contrasting with the yellow glow provided by the last of the daylight. There is a real feeling of bleakness to the finished painting. In reality the drystone walls did not quite oblige me with the diminishing, zig-zag line that leads the viewer right into the middle distance, but we can put that down to artistic licence.

Curbar Edge

482 x 280mm (19 x 11in)

This is another one of the 'Edges', which form a gritstone escarpment that runs along the eastern side of the Peak District in the UK, just a few miles from my Derbyshire home. This painting is very similar to *Baslow Edge*, but the sun is a touch lower, which really picks out the top edges of the rocks and boulders. I was also drawn to the ridge along the top edge of the distant landscape, which serves to lead our eye right into the distance.

Index

A Winter Walk
254 x 178mm (10 x 7in)
Not every painting has to be a carefully considered, major work. This forty minute watercolour sketch makes up in spontaneity for what it lacks in detail.